IMAGES
of America
ROSWELL

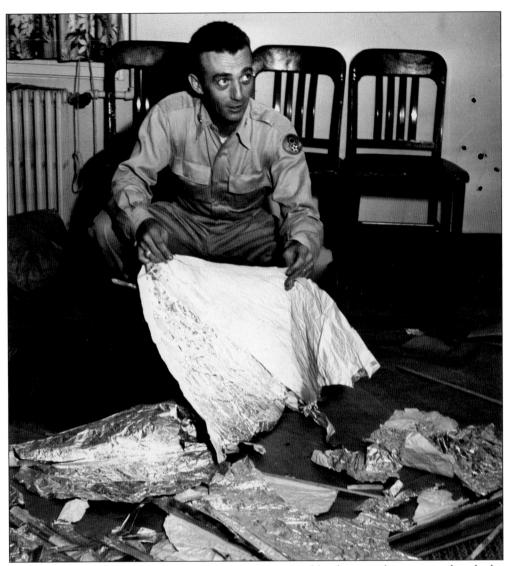

In what is perhaps one of the most iconic and recognizable photographs associated with the Roswell incident, Maj. Jesse A. Marcel poses with pieces of a weather balloon on July 8, 1947, in the office of Brig. Gen. Roger Ramey in Fort Worth, Texas. That same day, the *Roswell Daily Record* released the story that the Roswell Army Air Field (RAAF) had found a crashed flying saucer on a ranch northwest of Roswell near Corona. The military decided to cover the incident up by saying it was really just a weather balloon, hence Major Marcel, the RAAF's chief intelligence officer, posing with the weather balloon debris seen here. Many years later, in the 1970s, Marcel would say that the wreckage he was posing with in the photograph was not the real wreckage that he had brought to show General Ramey, as well as that it was his opinion that the real wreckage came from something not of this earth. (Courtesy *Fort Worth Star-Telegram* Collection, Special Collections, The University of Texas at Arlington Library, Arlington, Texas.)

ON THE COVER: The photograph shows the staff of Roswell's first newspaper, the *Pecos Valley Register.* Owner and editor J. A. Erwin is seated, while his wife, Nell G. Erwin, and her brother, Lou Fullen, stand on the right. (Courtesy Historical Society for Southeast New Mexico, #3424.)

IMAGES

of America

ROSWELL

John LeMay

ARCADIA
PUBLISHING

Published by Arcadia Publishing
Charleston, South Carolina

Printed in the United States of America

Library of Congress Catalog Card Number: 2008932135

For all general information contact Arcadia Publishing at:
Telephone 843-853-2070
Fax 843-853-0044
E-mail sales@arcadiapublishing.com
For customer service and orders:
Toll-Free 1-888-313-2665

Visit us on the Internet at www.arcadiapublishing.com

In memory of Ernestine Chesser Williams, Roswell writer and historian.

CONTENTS

ACKNOWLEDGMENTS

I'd first off like to thank Mike Smith, author of *Towns of the Sandia Mountains* and the man behind "My Strange New Mexico," for getting me involved with Arcadia Publishing.

Sometimes it really isn't what you know but who cares to look out for you in the publishing world that gets you started. Thanks, Mike.

Thanks to Jared Jackson, my editor; I couldn't have asked for a nicer boss on this project and greatly appreciate your patience and assistance in seeing it to fruition.

I must offer an especially big thank you to the Historical Society for Southeast New Mexico (HSSNM) and Elvis Fleming, who also took the time to proofread most of this work. Without Fleming's incomparable knowledge of Roswell's history and the monumental collection of photographs held in the HSSNM's archives, this book would by no means have been possible. Thanks Elvis, museum director Roger Burnett, Jim Bullock, Ken Case, Peggy Stokes, Madonna Darland, and all the other generous volunteers at the HSSNM for your help in one way or another.

To Laurie Rufe, director of the Roswell Museum and Art Center (RMAC); Candace Jordan Russell, RMAC librarian; and Caroline Brooks, RMAC assistant director; thank you for your kind cooperation in making available to me the NASA photographs of Robert H. Goddard as well as others from the museum.

For the picture of Pat Garrett on page 21, I thank Claudia Rivers at the University of Texas at El Paso for her prompt cooperation.

With regards to photographs pertaining to the Roswell incident, I thank researcher Dennis Balthaser for sitting down with me, looking the chapter over, and providing me with several great photographs and information. I also thank Dell Stringfield, Cathy Spitzenberger, Joe Brazel, Andrew Poertner, the International UFO Museum and Research Center, and Tom Carey for taking the time out of his busy schedule to provide me with many wonderful photographs and the whereabouts for their copyright information.

INTRODUCTION

Roswell has come a long way since it began as a mere trading post in the Pecos Valley along the Goodnight-Loving Cattle Trail back in the 1860s. From that one simple outpost, with the help and guidance of individuals such as Van C. Smith, John Chisum, Capt. Joseph C. Lea, J. J. Hagerman, and many others, Roswell grew to become the hub of Southeastern New Mexico. Today it is still growing and has a wonderful year-round climate, is a popular spot for retirees to settle, and also happens to be the dairy capital of the Southwest. But more important to the rest of the world, Roswell is that little town in New Mexico where aliens and a flying saucer crashed in 1947.

Thanks to pop-cultural references in films such as *Independence Day* and *Indiana Jones and the Kingdom of the Crystal Skull*, just about everyone thinks that's all there is to Roswell—the aliens—while in fact there is so much more.

Were it not for the Roswell incident, as it is popularly known thanks to the book of the same name by Charles Berlitz and William L. Moore, Roswell may very well have been famous for being the site of many of Dr. Robert H. Goddard's rocket tests in the 1930s. Or perhaps the town would merely be known as the stomping grounds of old-time celebrities such as Western film star Roy Rogers, aviator Charles Lindbergh, and rodeo champion Bob Crosby, to name a few, or the birthplace of more modern icons such as John Denver and Demi Moore, born here in 1943 and 1962 respectively. Maybe it would have been Roswell's military involvement harboring the 509th Bomb Group, the only elite atomic bomb squad in the world during its time at the Roswell Army Air Field south of town. Roswell is also home to the "West Point of the West," New Mexico Military Institute, whose former cadets include ABC news correspondent Sam Donaldson, artist Peter Hurd, Pulitzer Prize–winning author Paul Horgan, founder of the Hilton Hotel chain Conrad Hilton, Dallas Cowboys quarterback Roger Staubach, and actor Owen Wilson, to name a few. Or perhaps, like neighboring Lincoln County, Roswell's claim to fame would have been old-time Western figures such as cattle baron John Chisum and Sheriff Pat Garrett, who used to live in the area.

Whatever the case, fame or no fame, isn't Roswell still just another little town in the middle of nowhere? While it may indeed be in the middle of the prairie, events in this small town have had a unique impact on the world, one that many people may not comprehend. Its most profound and far-reaching impact comes in the form of Dr. Robert H. Goddard, whose experimental rocket launches eventually ensured us a journey to the moon. Goddard's rocket designs were copied by the Germans in World War II, when their V-2 rockets rained terror down upon London. Once Goddard inspected a captured V-2 rocket, his speculations were confirmed that the Germans had indeed used his rocket designs as a weapon. The U.S. Army had ironically ignored the concept of using rocketry for warfare earlier. Years later, Goddard's ideas paved the way to the beginning of the space age and inspired Werner von Braun, a world-renowned rocket scientist from Germany.

Not far from Roswell, a weapon that would usher the world into the atomic age would be tested in Alamogordo. Roswell was close enough to the Trinity Site near Alamogordo that residents were able to see the blinding light of the explosion. Some residents also say that during the Cold War

Era during the Cuban Missile Crisis of 1962 B-52s of the Roswell Air Base (then called Walker Air Force Base) sat on the base runway with engines running ready to take off and retaliate at a moments notice.

And then of course there's the Roswell incident of 1947, which if, like so many believe, it was the crash of an extraterrestrial spacecraft and not a top-secret, high-altitude weather balloon as claimed by the military, it could just about make Roswell one of the most historic spots on the planet. As Toby Smith makes a case for in his book, *Little Gray Men: Roswell and the Rise of a Popular Culture*, Roswell has more or less shaped the way people look at extraterrestrials, and most people are now certain that if aliens do in fact exist they must look just like the ones recovered at Roswell.

These were fairly far-reaching effects for a small town in the middle of nowhere. But, just as the amount of books written on Billy the Kid outnumber those written on the town of Lincoln itself where he roamed, fewer books have been written on Roswell the town than on the Roswell incident. So while the story of the UFO crash near Roswell will be told in this book, more importantly, so too will the town's rich history appear in the pages ahead.

Unlike most areas in New Mexico, Roswell's history does not begin with the Spanish exploration of the mid-1500s. The only Spanish explorers to go through the Pecos Valley included Antonio de Espejo in 1582 and Gaspar Castano de Sosa in 1590, and they recorded very little about the area. A few small petroglyphs exist in Bottomless Lakes State Park depicting the first Spaniards to traverse the Pecos Valley. Although some Mescalero Apaches roamed in the area, no other people or settlers would begin arriving in the area until after the United States had acquired the New Mexico territory in 1850 after the Mexican-American War and the resulting Treaty of Guadalupe-Hidalgo. The Pecos Valley's first settlers would come in the form of Hispanics that started the small communities of Missouri Plaza, Rio Hondo, and Berrendo in the 1860s. These settlements didn't last long, and Roswell would have its true beginnings in the form of the aforementioned small trading post built along the Goodnight-Loving Cattle Trail, and in a domino effect of events, Roswell would eventually be born and become the place that it is today.

One

THE FOUNDING
OF ROSWELL

The first building in Roswell was a single 15-foot-by-15-foot adobe room built by a man named James Patterson. Patterson used the structure as a trading post along the Goodnight-Loving Cattle Trail, which began in Graham, Texas, and went southwest to the Pecos River, then north through what would later became Roswell and from there to Fort Sumner, New Mexico.

Patterson did not keep the post for long and sold it to Van C. Smith in early 1870. Smith wasted no time in adding onto the small structure, expanding it into an all-in-one saloon, casino, restaurant, and hotel. Entering into a partnership with Frank Wilburn, Smith also built a general store. For several years, this small outpost was associated with the nearby Hispanic settlement of Rio Hondo before Smith named it Roswell, after his father, Roswell Smith, in 1872. However, it would not be recognized by this new name until 1873, when Smith opened the Roswell Post Office inside his general store in August of the same year.

Thanks to Smith's habits as a professional gambler, the town was a rather lively, and notorious, place to visit. In addition to card gaming, cock fighting, and dog fighting, Smith laid out two parallel half-mile racetracks, complete with a judge's stand, for horse racing. Gamblers would come all the way from Santa Fe to bet on horse races and fights, as well as poker games. Had Smith not been such a gambler, the town would have likely prospered and seen more settlers come in. Smith left the town for good in 1875, but more Wild West trouble was on the horizon with the advent of the Lincoln County War, of which Roswell would try to stay neutral.

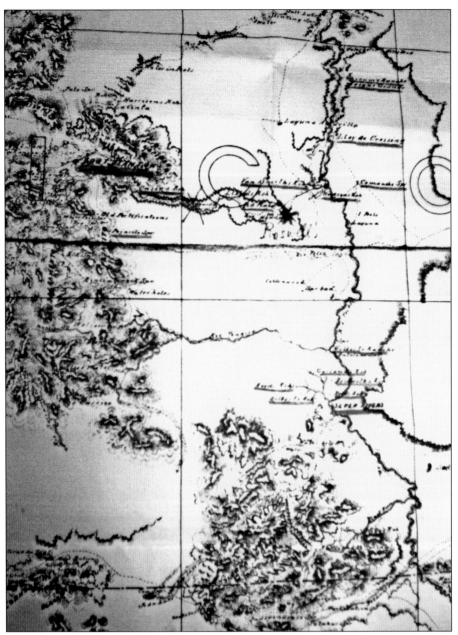

At the time of its founding, Roswell was part of massive Lincoln County, part of which is shown in the old map above. In Lincoln County, and several miles west of Roswell, was the town of Lincoln, which in the late 1870s was the central battlefield for the Lincoln County War. The war began when lawyer Alexander McSween, with the backing of English rancher John Tunstall and cattle baron John Chisum, opened up a store to compete with landowner Lawrence G. Murphy, who was monopolizing the area of Lincoln through his general store. This confrontation lead to the murder of Tunstall, in turn sparking the Lincoln County War and making legends out of its participants, such as William H. Bonney or "Billy the Kid" and his gang, the Regulators. With Roswell in such close proximity to Lincoln, it would be difficult for the town to stay out of the conflict. (Courtesy HSSNM.)

An important feature that brought early settlers to the Pecos Valley was North Spring River. Although the river would dry up some time in the 1920s, in its prime it was 40 to 60 feet wide in some places and 10 to 20 feet deep. (Courtesy HSSNM, #286D.)

Before the birth of Roswell, there were several other small settlements in the Pecos Valley, such as Rio Hondo, Berrendo, and Missouri Plaza around 1866. The settlements were mostly populated by Spanish Americans, although there were a few Anglo American families at Missouri Plaza. Shown here are the remains of the large corral of Missouri Plaza, which was completely deserted by 1871. (Courtesy HSSNM, #1493B.)

Since no known photographs exist of Van C. Smith, pictured here is a drawing by artist K. Gunnor Peterson based upon historical descriptions of Smith. Smith was born under the name of Van Ness Cummings Smith to Roswell and Harriet Smith in Ludlow, Vermont, in July 1837. Smith was also notable for being one of the founders of Prescott, Arizona, as well as being the first man to hold the office of sheriff in Arizona when the governor appointed him such in 1864. Despite his better qualities, Smith's downfall was his excessive gambling habit. As evidenced in the photograph below, much gambling and card playing took place in early-day Roswell, although the exact date and place this picture was taken is unknown. (Above, courtesy Stu Pritchard; below, courtesy HSSNM, #1776.)

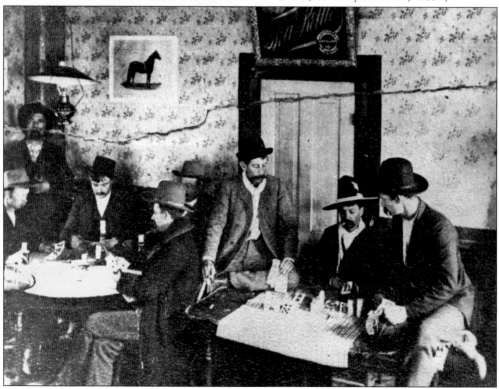

Pictured here are the first two buildings in Roswell as they appeared in 1883. Smith added additional rooms onto the original 15-foot-by-15-foot adobe structure he bought from James Patterson by bringing in adobe makers and layers from Lincoln as well as lumber and carpenters from Fort Stanton. Once it was finished, it became Roswell's first hotel, and a general store was erected next to it. (Courtesy HSSNM, #376B.)

Another prominent figure in early-day Roswell was Ash Upson, shown here in another drawing by K. Gunnor Peterson. Upson was an early postmaster in the town and also justice of the peace for a time. Upson is famous for ghostwriting Pat Garrett's *The Authentic Life of Billy the Kid*. (Courtesy Stu Pritchard.)

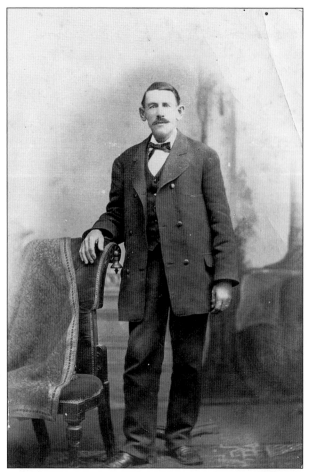

John Simpson Chisum, "Cattle King of the Pecos," came to the Pecos Valley with several thousand head of cattle in 1867. Chisum first set up a ranch north of Roswell but later moved to more permanent headquarters at South Spring River Ranch south of town. He was a prominent figure in the Lincoln County War and New Mexico history in general. Chisum was well known for his unique way of making his cattle recognizable and therefore difficult to resell after being stolen by cattle rustlers. In addition to branding his cattle, he also cut their ears down the middle, creating an effect famously called the "Jingle-Bob." In the photograph below are the many cowhands ready for roundup on Chisum's South Spring River Ranch. (Courtesy HSSNM, # 604D, #588.)

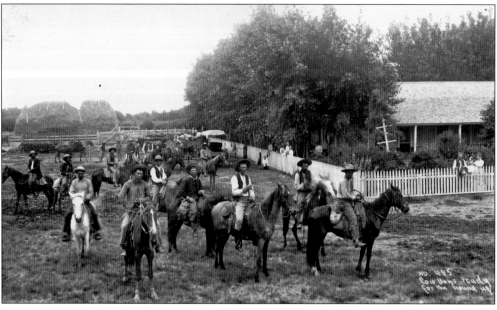

The lady of the house at John Chisum's South Spring River Ranch was Chisum's niece, Sallie Chisum, the daughter of his brother James. Sallie, only 18 years old at the time she moved from Texas to Roswell, won the affections of many a cowhand at the ranch. Sallie was also friends with Billy the Kid and he reportedly wrote to her often. (Courtesy HSSNM, #1924.)

During the time it was in operation, few other ranching outfits in the country could compare to John Chisum's South Spring River Ranch. The house, an adobe structure consisting of nine rooms in a line, was famous for its extravagant long porch. Many people, outlaws and dignitaries alike, visited and stayed at the ranch, including Pat Garrett and Billy the Kid. (Courtesy HSSNM, #1564-63.)

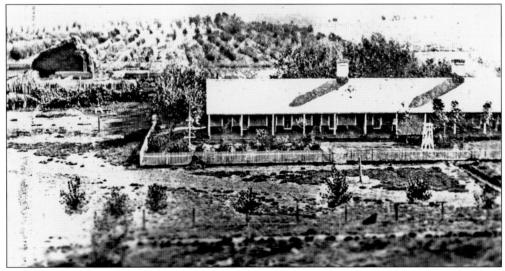

John Chisum had two brothers, Pitzer and James, that moved with him to the Pecos Valley to help run the ranch. Jointly, they planted and bound three cottonwood trees together so that they eventually grew as one, signifying their close relationship. James Chisum's children (from left to right) Walter, Sallie, and Will, are pictured here. (Courtesy HSSNM, #2199.)

The man on the chuck wagon is Frank Chisum, a slave John Chisum took a fatherly interest in when Frank was a boy. Chisum acquired Frank and his younger brother in Bolivar, Texas. When slaves were emancipated, Frank chose to stay on with Chisum at his ranch. (Courtesy HSSNM, #855.)

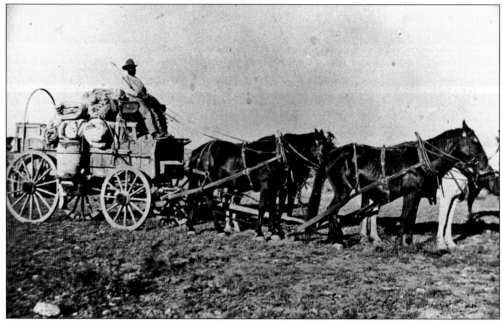

Thanks to his "Uncle John," John Chisum, Frank was one of the wealthiest African American cattle owners, if not the wealthiest, in the territory. He stayed in Roswell for many years after John Chisum's death. Frank died in Wichita Falls, Texas, on March 6, 1929, and is buried there in the Lakeview Cemetery. (Courtesy HSSNM, #3872.)

Juan Chavez was one of the earliest Hispanic settlers in Roswell. Here he stands in front of his adobe home. Chavez lived in close proximity to the Pecos River and operated Juan Chavez Crossing with his ferryboat, which he used to ferry people and their horses across the Pecos. He operated the business until a bridge was finally put over the Pecos in 1902. (Courtesy HSSNM #4825.)

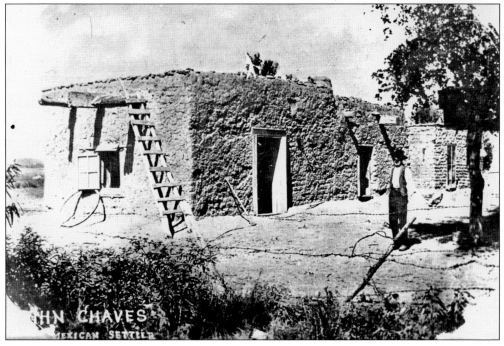

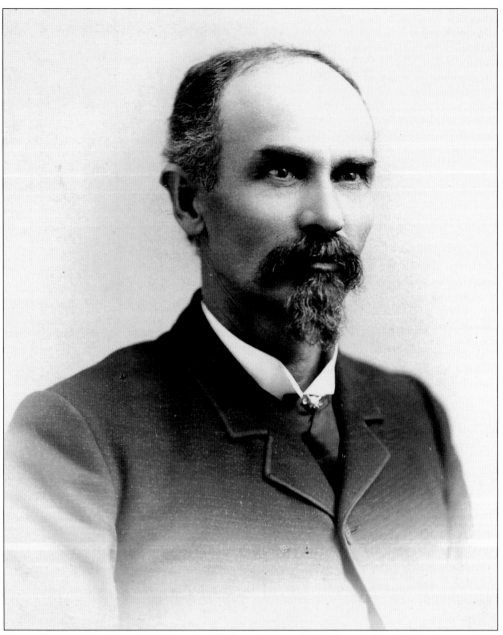

Shown here is Capt. Joseph C. Lea, the "Father of Roswell." Although Van C. Smith may have been Roswell's founder, Lea was the man who stuck around to cultivate the town's best interests. Lea was born in Cleveland, Tennessee, on November 8, 1841. At the outbreak of the Civil War he was part of the Confederate army and retired with a major's commission, although he chose to stick with the title of captain. For a time he engaged in cotton planting in the South before moving west to New Mexico to give ranching a try, at first moving to Colfax County in the vicinity of Elizabethtown. Lea's father-in-law, "Major" W. W. Wildy, also came to New Mexico looking for investments, heard of Roswell in 1877, and soon purchased some land there. Lea and his wife soon followed Wildy to Roswell and eventually acquired the store and boardinghouse previously owned by Van C. Smith. (Courtesy HSSNM, #495A.)

This *c.* 1883 image shows Captain Lea's wife, Sallie Wildy Lea, and two children, Ella and Wildy. Captain Lea began courting Sallie, the daughter of established cotton planter "Major" W. W. Wildy, in Yazoo County, Mississippi. The two were married February 3, 1875, after which Lea immediately set out for the New Mexico territory. (Courtesy HSSNM, #3340.)

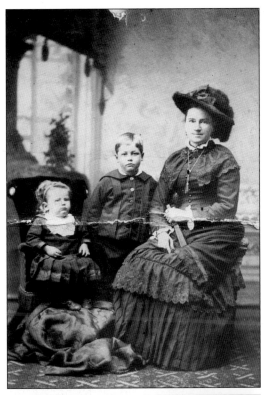

Captain Lea allowed for no trouble in his new town. When rowdy cowboys rode into Roswell firing their pistols, Captain Lea promptly came out with his Winchester and told the men they were welcome in town as long as they caused no trouble, at which point they quietly left. Shown here are many of the town's early residents standing to the side of Lea's boardinghouse. (Courtesy HSSNM, #972.)

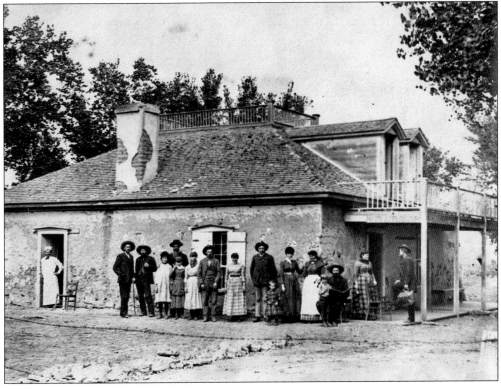

19

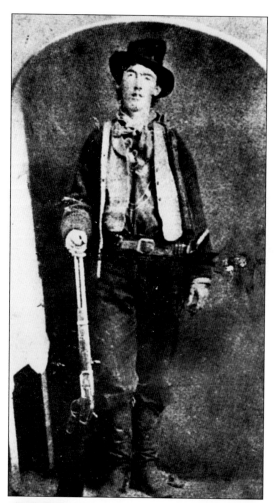

Lincoln County outlaw William H. Bonney, also known as Billy the Kid, kept out of Roswell for the most part due to the efforts of Capt. Joseph C. Lea, who told him that if he ever caused trouble in Roswell he would be shot. According to Elvis E. Fleming's Captain Lea biography, Billy replied, "All right Cap'in. I promise I won't ever cut up any capers in your Roswell." (Courtesy HSSNM, #2195A.)

These ruins east of Roswell, called "The Skillet," were an alleged hideout of Billy the Kid. However, as noted Southeastern New Mexico historian Elvis E. Fleming jokes, "If Billy the Kid actually hid out all the places people say he did then he would have probably never had time to rustle any cattle." (Courtesy HSSNM, #3415.)

Pictured here is famous lawman Sheriff Pat Garrett. Garrett was born June 5, 1850, in Alabama and led a life of adventure and controversy. He started out as a buffalo hunter in Texas before coming to New Mexico in the late 1870s, where he became a bartender and befriended Billy the Kid. Years later, when Billy became a nuisance to Lincoln County rustling too many cattle, Garrett would become sheriff and hunt him down. Garrett also called the Roswell area home for eight years from 1880 to 1888. He can be seen in the bottom photograph, sitting at the far left, with other cowboys during roundup time at North Spring River in 1888. (Right, courtesy of University of Texas at El Paso, Special Collections Department; below, courtesy HSSNM #566.)

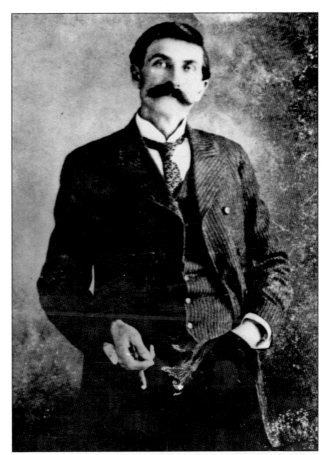

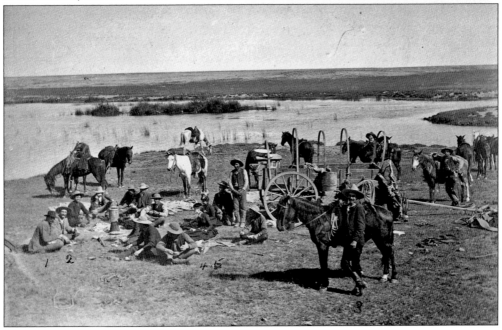

Pat Garrett, who had been living in Fort Sumner, was urged to move to the small hamlet of Roswell, pictured above in 1888, in time to qualify to run for sheriff of Lincoln County at the behest of John Chisum and Capt. Joseph C. Lea. With the backing of these two powerful individuals, Garrett won and began his duty to hunt down his former friend, Billy the Kid. Garrett, his wife, Apolinaria, and three of their children sit outside of their Roswell home in the bottom photograph. The house was built in 1880 on a 160-acre homestead. One of the children in the photograph is likely Elizabeth Garrett, who would one day grow up to write the New Mexico state song, "O Fair New Mexico." (Courtesy HSSNM, #587A, #1887.)

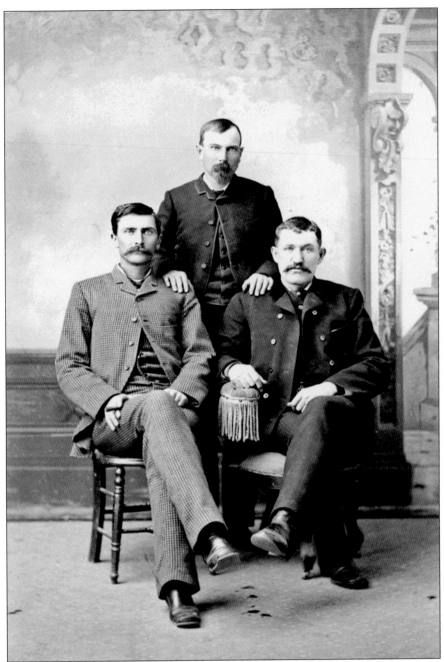

Pat Garrett, seated to the left, poses with two fellow sheriffs of Lincoln County, John W. Poe (sitting at right), his former deputy, and James R. Brent. On the night of July 14, 1881, Garrett finally tracked down Billy the Kid in Fort Sumner and shot him dead. Garrett himself was gunned down years later outside of Las Cruces, New Mexico, in 1908 over a dispute involving grazing rights on his land. The shooter was Jesse "Wayne" Brazel, none other than the second cousin of William "Mack" Brazel, who, in 1947, would stun the world as the rancher who found the flying saucer debris outside of Roswell near Corona. Garrett's death is shrouded in conspiracy, and historians now believe that Brazel was not the actual shooter. (Courtesy HSSNM, # 463.)

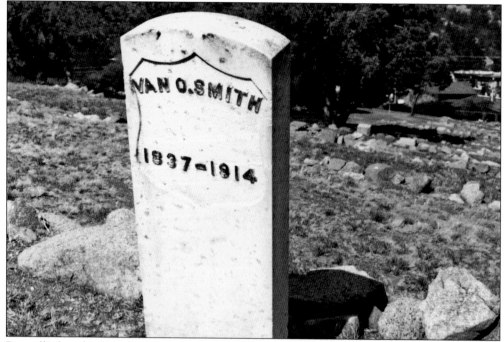

Roswell's founder, Van C. Smith, died in Prescott, Arizona, on August 29, 1914. After leaving Roswell, Smith continued his adventuresome ways as a casino owner in Santa Fe, Indian scout and deputy sheriff in Arizona, and as a rancher and prospector in Mexico. He is buried in the Arizona Pioneers Home in Prescott, Arizona. (Photograph by Elvis E. Fleming, courtesy HSSNM #4711.)

John Chisum died on December 20, 1884, and was laid to rest in Paris, Texas, the town he lived in during his youth. His memory is forever immortalized in the 1970 film *Chisum*, in which John Wayne portrays the title role, and by a bronze statue in his image that stands in downtown Roswell today. (Courtesy HSSNM, # 4041B.)

Two

A Growing Township

With the bloodshed of the Lincoln County War behind the New Mexico territory, the town of Roswell was able to grow in leaps and bounds. Thanks to the stable leadership of Capt. Joseph C. Lea, more and more settlers, many of them ranchers and farmers, began to see Roswell as a suitable place to homestead. Among Captain Lea's first orders of business were to begin developing a series of irrigation canals to water the Pecos Valley and to plant a plethora of trees.

With the township of Roswell having grown into 10 houses, Captain Lea felt it was time to plat the streets. In 1884, Captain Lea's brother Alfred E. Lea was called in to survey Roswell and draw up an official plat, which was finished and certified as of November 1, 1885.

Lea also had his own cattle company at the time, Lea Cattle Company, which some say was the largest ranching outfit in New Mexico at the time after the passing of John Chisum. As for Lea's general store, he also had a new partner, C. D. Bonney Jr. The store was promptly renamed Lea, Bonney and Company and would retain the name even after it was bought by William H. Cosgrove a short time later. Lea sold the store after the death of his beloved wife, Sallie, in 1884.

As the town kept growing, a two-room schoolhouse was built in 1885. Roswell also got its first permanent blacksmith when Rufus H. Dunnahoo moved to town in 1881. Roswell's first industry was established in the form of Blashek's Mill, producing flour and meal.

Many of Capt. Joseph C. Lea's relatives would move to Roswell in the early 1880s, including his younger brother, Frank H. Lea. Frank would build one of the first houses in Roswell, and he was also the first to settle in White Oaks, New Mexico. Frank, the second man from the left, is pictured later in life at his home in 1897. (Courtesy HSSNM, #462D.)

In a marriage arranged by Capt. Joseph C. Lea and Sheriff Pat Garrett, Sophie Alberding married John W. Poe in 1883. Poe was one of Garrett's deputies the night he shot Billy the Kid in Fort Sumner. Poe would later be elected sheriff of Lincoln County himself and in Roswell's future became a prominent banker. (Courtesy HSSNM, #1206.)

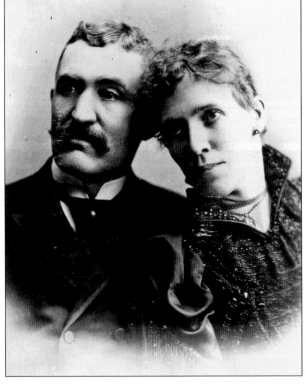

After the loss of her husband, Captain Lea's younger sister, Ella Lea Calfee, moved to Roswell with her two sons in 1880. Immediately after arriving, Ella Lea invested in many local projects in Roswell. In 1881, she became a partner in the North Spring River Centre Ditch Company, and she also bought John Chisum's former Bosque Grande headquarters north of town. (Courtesy HSSNM, #488A1.)

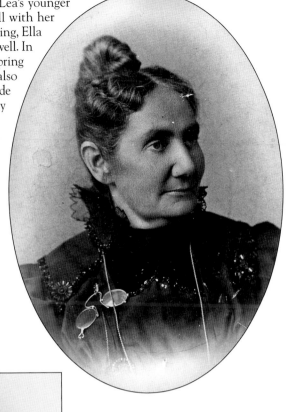

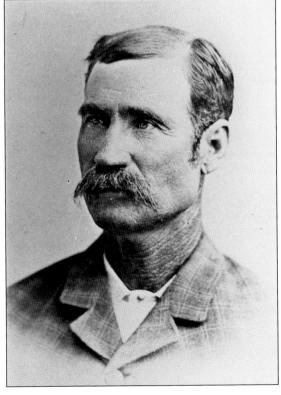

Lincoln County War veteran Milo Pierce married Ella Lea Calfee in 1882. Pierce, who was part of the Murphy/Dolan faction in the war, was crippled due to a gunshot wound to the hip accidentally inflicted by Robert "Pecos Bob" Olinger, the man who would later be killed by Billy the Kid during his famous escape from the Lincoln County Courthouse. (Courtesy HSSNM, #488A2.)

In the fall of 1886 Roswell got its first true department store, Jaffa, Prager and Company, established by Nathan Jaffa and Will Prager, which sold everything from clothes to groceries. The two had first opened the store at John Chisum's old ranch earlier that year but later moved it to town. The store can be seen in the photograph of Roswell above to the far right. Photographed in front of the store in the picture below, from left to right, are George Hafley; Sidney Prager; Will Prager; Nathan Jaffa; Homer Clarkson; Roswell's first doctor, James W. Sutherland; Pat Garrett; and Neighbor Gayle. (Courtesy HSSNM, #587B, #2914.)

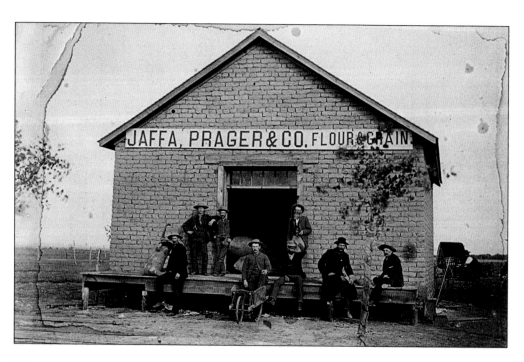

Shown here are Austrian-born George Blashek (right) and his son Frank. George Blashek, with the help of Capt. Joseph C. Lea, started Blashek's Mill which began producing flour and meal in 1893. Blashek's family would live in Roswell for the next 90 years, and his son Frank would even operate the mill sporadically up until World War II. (Courtesy HSSNM, #1200.)

Soon more and more settlers began arriving in the Pecos Valley, many of them farmers. One of the most prominent of these settlers was Martin Van Buren Corn, who came to the Roswell area with his large family in the latter half of the 1870s. Many of Corn's descendants still live in Roswell today. Here an unidentified man stands in Corn's cornfield. (Courtesy HSSNM, #334.)

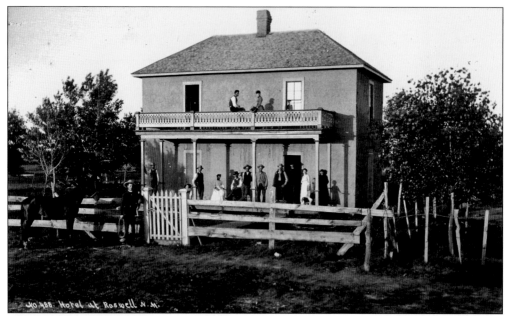

This hotel was the first two-story building to be built in the Pecos Valley. In the years to follow, many more two-story buildings would pop up in Roswell along Main Street. (Courtesy HSSNM, #592.)

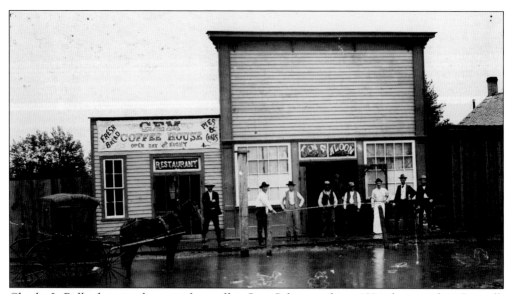

Charles L. Ballard sits in a buggy in front of his Gem Saloon in this c. 1894 photograph in Roswell. Ballard led an interesting life, serving in the Rough Riders, the legislature, and even as the last territorial sheriff of Chaves County. (Courtesy HSSNM, #2906.)

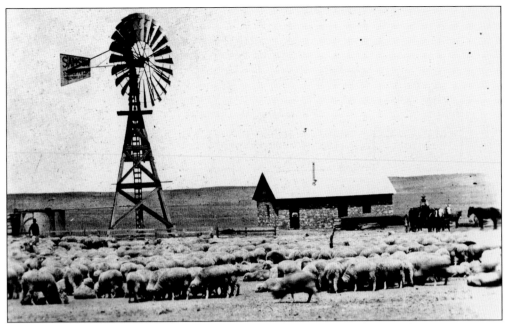

Sheep ranches, such as the Yoder Ranch shown here, became another staple of the Pecos Valley beginning as early as the late 1870s. One of the first and most prominent of the "sheep men" was James M. Miller, who bought his first sheep from Capt. Joseph C. Lea. Lea had tried to range sheep and cattle on the same land but found the endeavor unsuccessful. (Courtesy HSSNM, #670.)

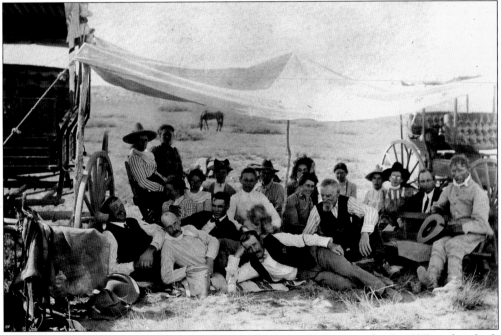

One of the more prominent cattle ranches in the Pecos Valley was the Bar V Ranch, which operated successfully from 1884 to 1909. It was operated predominantly by the Cooley and Urton families, who had come to New Mexico from Missouri. This photograph shows some of the Bar V family on a picnic. (Courtesy HSSNM, #009.)

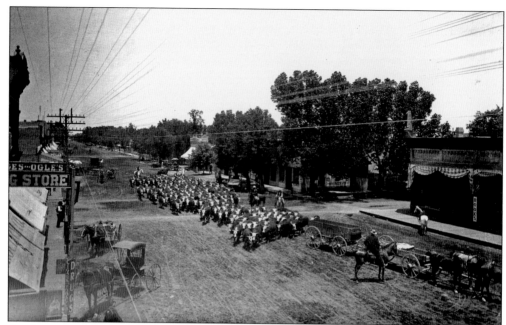

Cattle ranching has been a big part of Roswell life for many years, as evidenced by this photograph of Hereford cattle being herded down Main Street at the beginning of the 20th century. Capt. Joseph C. Lea got into the cattle business as well in 1884 with his Lea Cattle Company. Lea also had a partner in his company, Horace K. Thurber, who lived in New York. Although the company was successful, with Lea being the largest cattle holder in the territory, he and Thurber had a very strained relationship. A stock share from his business can be seen below. (Above, courtesy HSSNM #514; below, HSSNM #980109.)

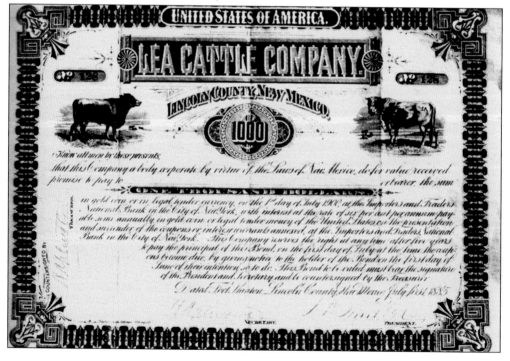

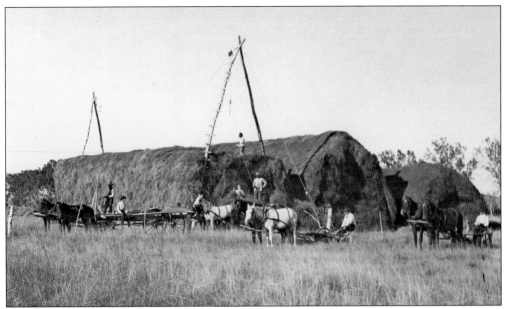

Alfalfa, because it is resilient to droughts and good food for livestock, was one of the most popular agricultural industries in Roswell. This photograph, taken in the late 1880s or early 1890s, shows the harvesting of a large amount of alfalfa as hay. (Courtesy HSSNM, #1820.)

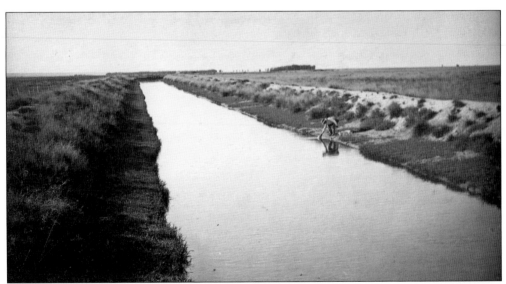

Irrigation canals such as this one were a large part of Roswell's continuing development. One of the first large irrigation projects was North Spring River Centre Ditch Company, formed by Capt. Joseph C. Lea, Ella Lea Calfee, Pat Garrett, and Barney Mason in 1881. Garrett invested in another irrigation company in 1888 called the Pecos Valley Irrigation and Investment Company with Charles B. Eddy and several others. (Courtesy HSSNM, #1814.)

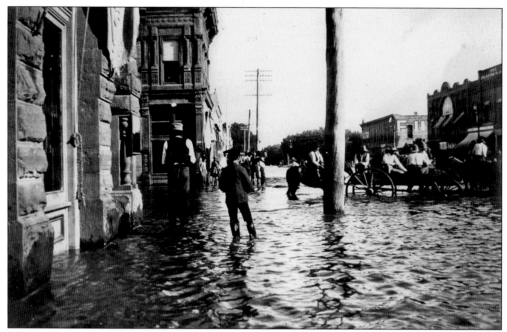

Despite the tremendous growth Roswell saw towards the end of the 19th century, it had its fair share of setbacks as well. In 1893, several buildings on Main Street burned down in a fire, and a bad flood occurred in that same year. Roswell was beset by floods quite often; the one in this photograph took place in 1904. (Courtesy HSSNM, #325A.)

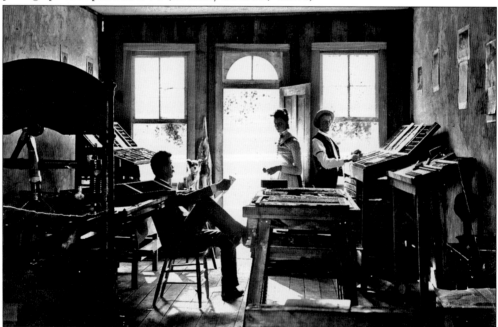

In November 1888, Roswell got its first newspaper, the *Pecos Valley Register*, which was printed weekly and delivered every Saturday. Owner and editor J. A. Erwin is seated, while his wife, Nell G. Erwin, and her brother Lou Fullen stand to the right. Together the three of them comprised the paper's entire staff. (Courtesy HSSNM, #3424.)

Roswell's first church, the First Methodist Episcopal Church, was finally built in 1888 and used for 10 years. Before the building of the First Methodist Episcopal Church services and Sunday school was held in the town schoolhouse, shown above. Several other churches were built in later years, such as the First Christian Church by the Disciples of Christ of Roswell in 1892. Baptists and Presbyterians followed and built churches later in the 1890s as well. Roswell was very much a strong Christian community, and the c. 1894 photograph below shows a baptism at North Spring River. (Courtesy HSSNM, #4812, #5110.)

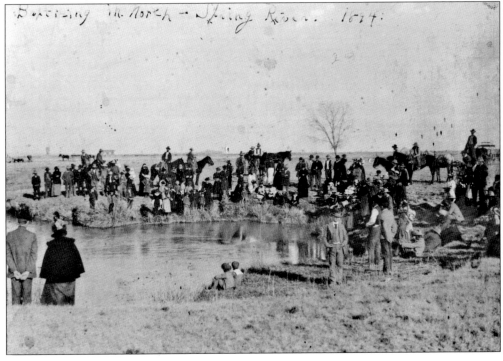

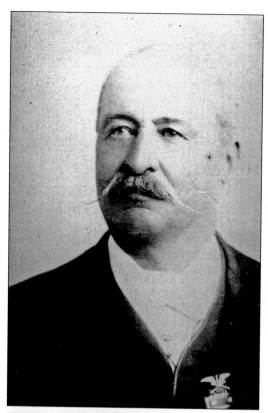

As the population of the Pecos Valley continued to grow, and being that there was a good distance between Roswell and the county seat in Lincoln, it was decided Roswell was large enough to become the seat of its own county. So Capt. Joseph C. Lea, Charles B. Eddy, and Pat Garrett traveled to Santa Fe to see the Territorial Council and House with a petition requesting that two new counties be carved out of Lincoln County. On February 25, 1889, the legislature passed the bill creating Chaves and Eddy Counties. Captain Lea, who would not allow Roswell's county to be named after himself, named it after his friend Col. J. Francisco Chaves, pictured to the left. A courthouse was erected in Roswell in 1890 and the building, shown below, was used up until 1910. (Courtesy HSSNM, #2359, #747A.)

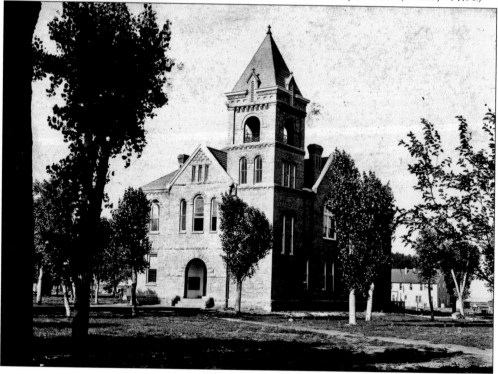

In 1890, the town of Roswell made the monumental discovery that it was sitting on top of a huge artesian reservoir, and it all happened purely by chance. Nathan Jaffa, tired of having to get his drinking water all the way from North Spring River, decided to drill for water in his back yard. What he found was beyond anyone's expectations. When the drilling machine, owned by William Hale, broke through a layer of porous limestone at a depth of 250 feet, pure, clear water shot to the surface. Soon more wells were found, among them some of the largest artesian wells in the world. As Lucius Dills, an early Roswell newspaperman, wrote, "The little frontier town went wild. Water meant more to them than a streak of placer dirt." (Courtesy HSSNM, #1816, #1613.)

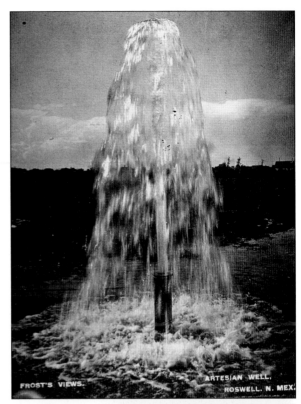

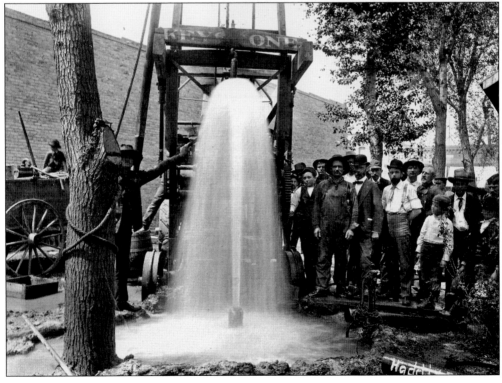

While on a trip to buy cattle for Lea Cattle Company in Texas, Capt. Joseph C. Lea met his future spouse, Mable Doss Day, a widow who some called the "Cattle Queen of Texas" since she was proprietor of her late husband's large ranch. Lea courted Day for four years, and the two were married in her ranch house on April 29, 1889. Mable Doss Day Lea then left the ranch in the hands of her brother, William H. Doss, and headed to Roswell along with her young daughter. In this photograph is the blended family of Captain Lea and Mable Doss Day Lea with children (from left to right) Ella Lea, Willie Day, and Wildy Lea on January 1, 1891. (Courtesy HSSNM, #2134A.)

Three

INTO THE 20TH CENTURY

A lot was happening in Roswell in the 1890s before the onset of the 20th century. Roswell had become its own county seat with a population of around 340 people, and the discovery of artesian water attracted hundreds upon hundreds of new settlers into the region. The cultivation of the previously dry land by this newfound water also brought about several new towns near Roswell, including Artesia, Dexter, and Hagerman. The Oasis Well near Roswell was said to be the largest artesian well in the world, and nearly 60,000 acres of land in the area, including farms, orchards, and ranches, were all irrigated by the water from the wells.

With Roswell now officially a county seat, it was also time to vote upon a town board of trustees. The board of trustees, consisting of Frank Lesnet, Jesse Smith Lea, S. S. Mendenhall, E. H. Skipwith, Nathan Jaffa, and the town marshal Henry Wright, were sworn into office by Hon. Frank H. Lea in 1891. Their first orders of business were coming up with a property tax to ensure more money went into Roswell's development, a dog control ordinance, and a speed limit of eight miles per hour for horses and carriages going down Main Street.

By 1899 the telephone, and telephone poles, had finally come to Roswell via the Roswell Telephone and Manufacturing Company and by 1901, one hundred fifty-seven local phones were in existence in the town. Roswell would also gain its own ice factory, steam laundry service, cigar factory, fire department, railroad, the prestigious New Mexico Military Institute, and its first bands and clubs. Electricity would finally become available in the town by 1901. It was also during these years that Roswell's dairy industry began to develop. Today the Roswell area is known as the Dairy Capital of the Southwest.

Thanks to all these developments, Roswell's population grew in only 10 years from that of 340 people in 1890 to 2,049 in 1900.

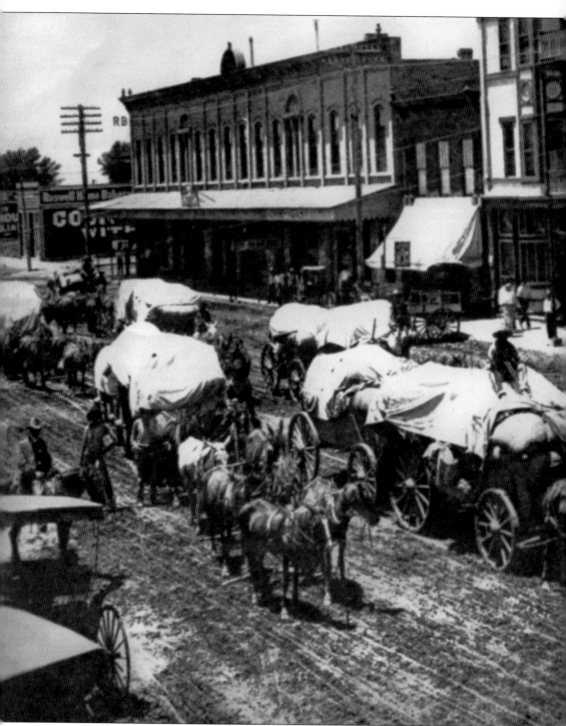

This photograph displaying Roswell's bustling Main Street was used at the time to advertise the town. Judging by the telephone lines in the photograph, it was taken sometime after 1900. The caption originally accompanying it read: "For anyone who despaired of making his fortune in the cities of the East, there was always a second chance in the vast, restless west. Board houses

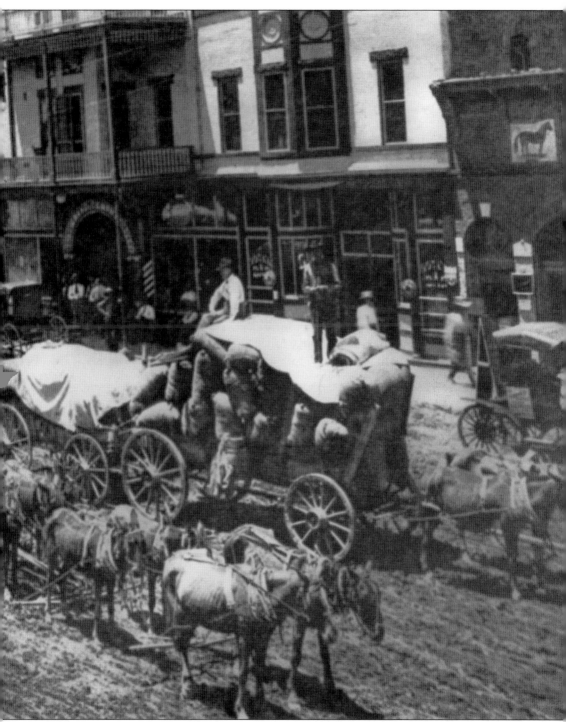

lined muddy streets where raw new cities sprang up at railheads, water holes and mines. With nerve and imagination, a man could run a grubstake into a fortune—and as easily lose his whole wealth trying to double it." (Courtesy HSSNM, #1649.)

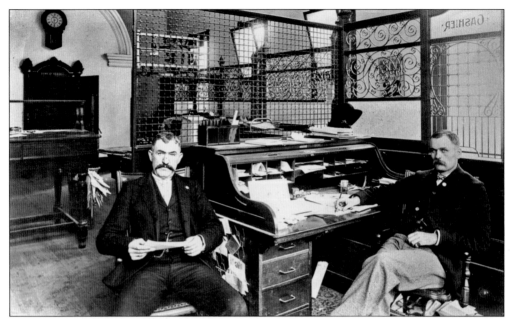

In 1890, E. A. Cahoon came from Albuquerque to establish the first bank in Roswell. The Bank of Roswell was first located in the lobby of the Hotel Pauly and opened in July 1890 with a capital of $50,000. Shown here are John W. Poe (left) and E. A. Cahoon (right) sitting behind the counter. The bank moved to its own building in 1894. (Courtesy HSSNM, #347A.)

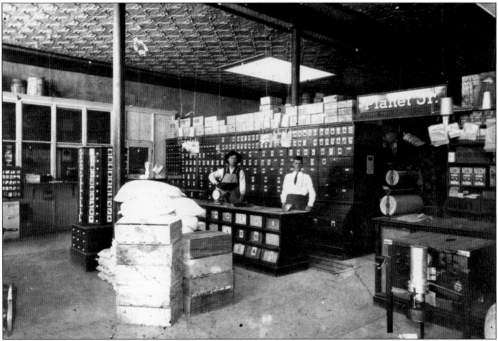

In 1903, John B. Gill started the Roswell Produce and Seed Company, whose name he shortened in 1908 to Roswell Seed. It is today the oldest business in Roswell, still owned and operated by Gill's descendants. The metal drawers behind the two employees are still in the store to this day. (Courtesy HSSNM, #1775.)

Out of all the early newspapers in Roswell only one has prospered to this day, the *Roswell Daily Record*. The *Roswell Daily Record* began as the *Roswell Record*, published by (seated from left to right below): editor Lucius Dills and Jennie Lea; (standing) owner Joe Lea, C. J. McDougall, and C. E. Bull. In 1902, the paper was taken over by H. M. F. Bear, who increased publication from once a week to daily, hence the name change to *Roswell Daily Record*. Pictured at right is the original office of the *Roswell Daily Record* with owner Bear and partner Charles E. Mason. Today the paper is best known for the headline that shocked the world in 1947 reading, "RAAF Captures Flying Saucer On Ranch in Roswell Region." (Courtesy HSSNM, #704A, #461.)

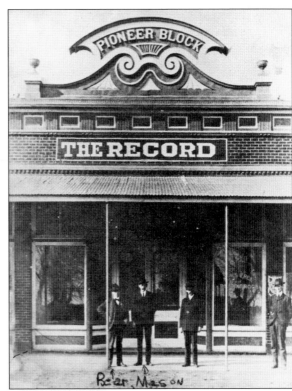

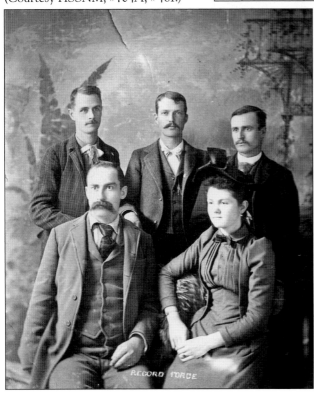

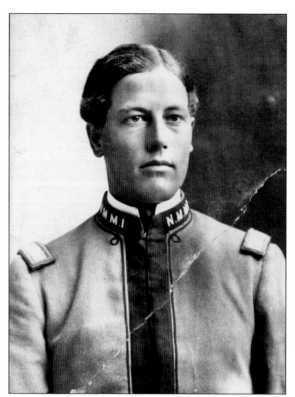

The birth of the New Mexico Military Institute (NMMI) is partially thanks to the wild ways of Wildy Lea, whom his father, Capt. Joseph C. Lea, wished to send away to a military reform school in hopes that it would rid him of undesirable habits picked up from local cowhands. Wildy Lea is seen here wearing the NMMI uniform later on, after it was officially founded. (Courtesy HSSNM, #3341.)

Capt. Joseph C. Lea sent his son, Wildy Lea, to Fort Worth University under the command of Col. Robert Goss in Texas. After some persuasion, Lea was able to convince Goss to start Goss Military Institute in Roswell. Goss is shown reclining on the ground in front of the artesian fountain along with his students and fellow instructors in this *c.* 1892–1894 photograph taken in Roswell. (Courtesy HSSNM, #2120.)

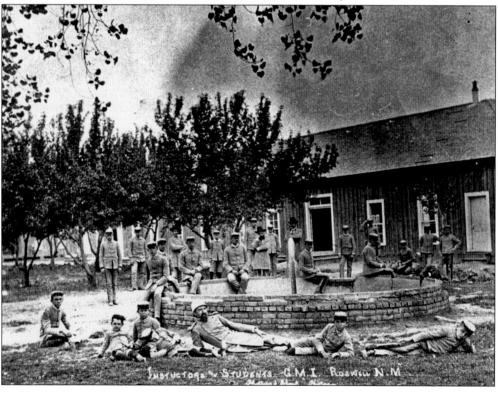

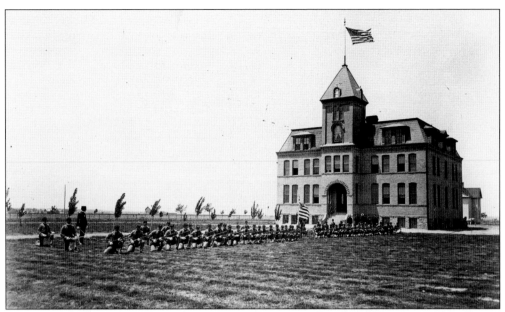

In February 1893, under a bill passed by the territorial legislature, Goss Military Institute was changed to New Mexico Military Institute so that it could be recognized by the territorial government and get more financial support. Although the school saw some hard times, with Col. Robert Goss leaving in the spring of 1893 and the institute temporarily closing down for three years, it bounced back. In March 1898, Lea Hall, named after Capt. Joseph C. Lea and shown above, was erected. Several smaller buildings would soon follow. On September 6, 1898, the term in the new building began and NMMI was formally opened with 200 residents showing up for the opening ceremonies. The photograph below shows the cadets inside their new classroom. (Courtesy HSSNM, #165T, #1626B.)

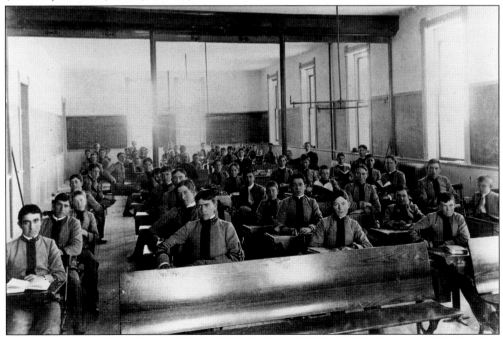

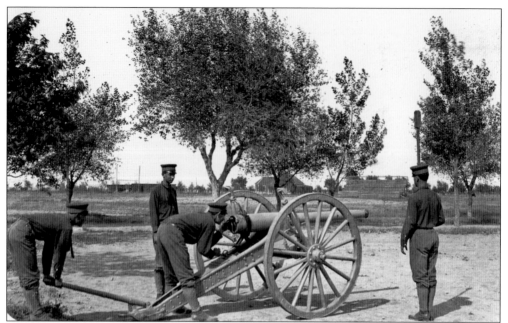

Before New Mexico Military Institute's formal opening in 1898, female students were permitted to go to school there, as well as "day students," who did not board at the school. When Col. James W. Willson was hired, he made the decision to no longer allow day or female students, as he felt them disruptive. Here some of the male cadets inspect one of the cannons at NMMI. (Courtesy HSSNM, #1154.)

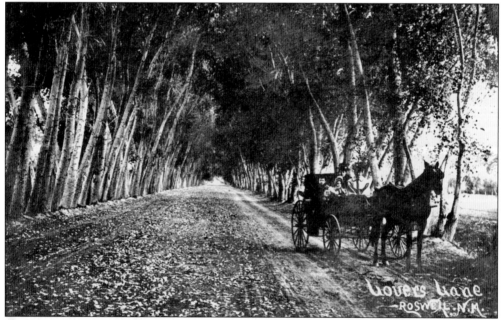

In its early years, Roswell was renowned as a city of trees, making it an oasis in the desert. Many had been planted there even before the discovery of artesian water, and more were planted thereafter. This lovely grove a few miles outside of Roswell was popular for carriage rides and was called Lover's Lane. (Courtesy HSSNM, #1810.)

Another giant of a man to come to the Pecos Valley like John Chisum and Capt. Joseph C. Lea before him was J. J. Hagerman (shown at right). Hagerman first became involved in the area thanks to investing in the Pecos Valley Irrigation and Investment Company. Once he saw the Pecos Valley for himself, Hagerman decided to move there. Appropriately, he bought property and built a three-story home on John Chisum's old South Spring River Ranch. The Hagerman Mansion, as it was called, is pictured in the *c.* 1907 photograph below. Also on South Spring River Ranch was the Hagerman Orchard, which town residents speculated could be the largest such apple orchard in the world during the time it was in operation. Hagerman later founded his own town, at first called Felix and later Hagerman, 22 miles south of Roswell. (Courtesy HSSNM, #555B, #586.)

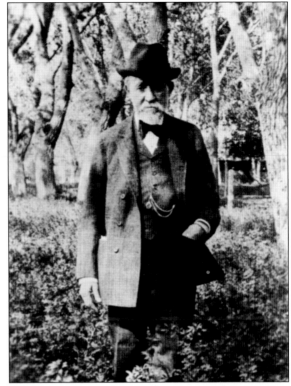

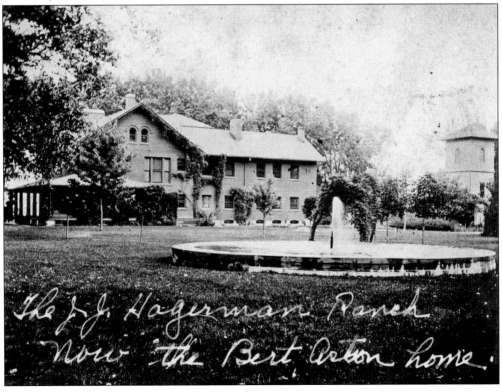

47

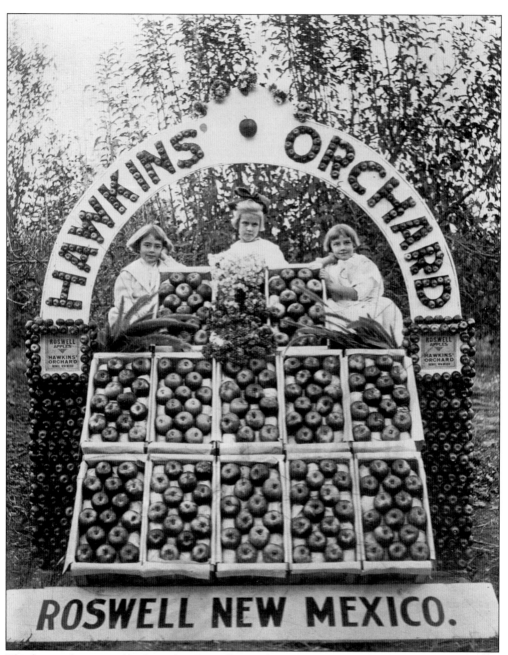

The first apple trees to be planted in Roswell were done so by James Chisum at the South Spring River Ranch in the late 1870s. More orchards were planted when water became readily available after the discovery of artesian water in the area. Although the Hagerman Orchard was the biggest in Roswell, there were also several others. So many, in fact, the town even had a holiday—Apple Blossom Day—celebrated once a year each spring. Newspaper records from that time show that in 1901, it was reported that 69 trainloads of 1.656 million pounds of apples were harvested and sent from Roswell. These three girls (from left to right), Chas Loomis, Mabel Cahoon, and Eleanor Bedell, pose behind a large apple display belonging to Hawkins's Orchard on November 13, 1903. (Courtesy HSSNM, #338.)

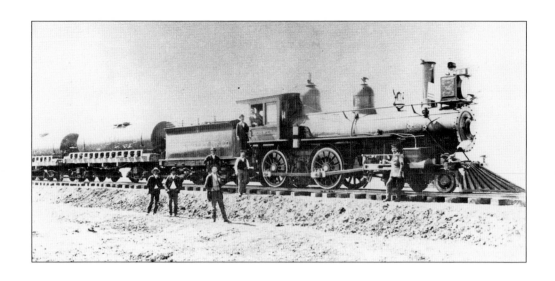

On October 6, 1894, the railroad finally came to Roswell. The man primarily responsible for this was J. J. Hagerman. Hagerman's first thought upon arriving in Roswell was that the city needed a railroad system as a means to transport its goods to eastern markets. Hagerman set up the Pecos Valley Railroad Company in 1891, and by 1894, the railroad had extended to Roswell from the nearby town of Eddy (today Carlsbad). The train arrived to great fanfare, and nearly half of Roswell's total population was said to have shown up to greet it, as illustrated in these photographs taken on the day of arrival. Capt. Joseph C. Lea stands in between the engine and the coal car in the above photograph. (Courtesy HSSNM, #2022A, #311.)

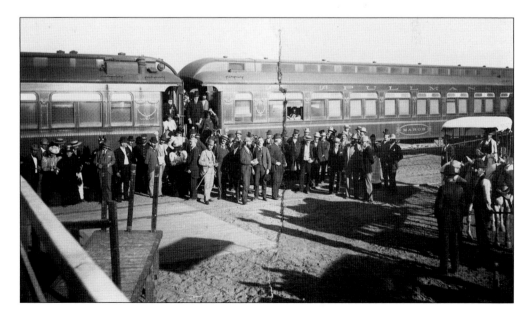

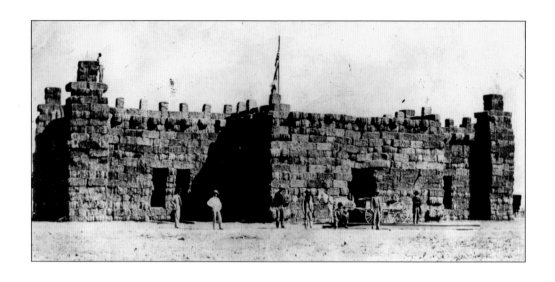

In the fall of 1893, the second annual meeting of the Southeastern New Mexico and Pecos Valley Fair came to Roswell with great fanfare. Especially unique to the fair was the famous Alfalfa Palace, the second ever to be constructed in America. The palace, as its name suggests, was built of alfalfa bales, and inside were exhibits of corn, onions, pumpkins, potatoes, and more. The fun was almost ruined though by strong winds that blew off some of the bales from the palace, causing the people inside to flee. At the fair there were also art and photography exhibits, a ladies textile department, and horse races. The fair took place October 3–7, 1893. (Courtesy HSSNM #679, #4848.)

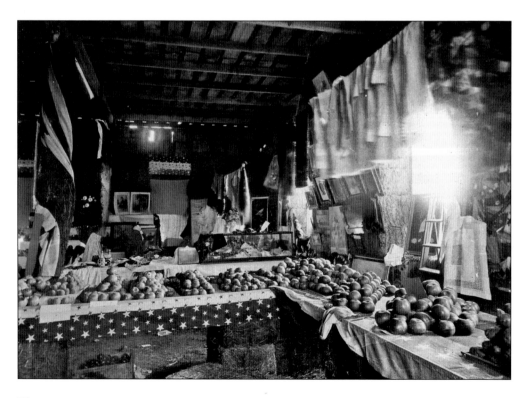

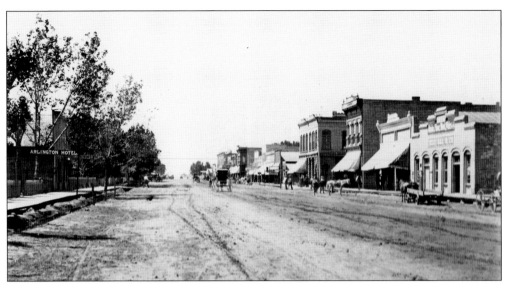

Roswell's Main Street is pictured here in 1900. By this time, Roswell had a population of 2,049 according to the then-current census. In 1903, Roswell was officially incorporated as a city instead of a town and had its boundaries expanded. This brought in an additional population, bringing the number up to 4,500 residents. (Courtesy HSSNM, #1819B.)

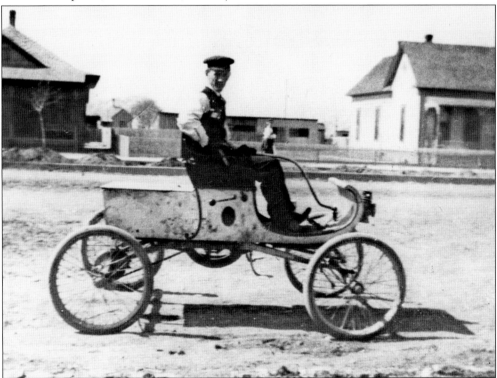

The first automobile to arrive in Roswell came in 1901. It was an Oldsmobile bought by Dr. W. E. Parkhurst from Lansing, Michigan. An old Roswell newspaper reported that, "[Parkhurst] set it up at the home of Mr. George E. Mabie, and as soon as he has learned to run it, will have it 'down town.'" Walter Gill is posed in the car here. (Courtesy HSSNM, #1767.)

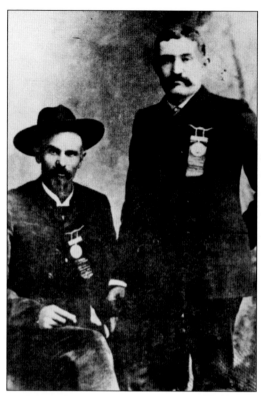

With Roswell now officially incorporated as a city, it was time to select city officials. Capt. Joseph C. Lea, sitting next to John W. Poe, was chosen by the Democrats to run for mayor. Captain Lea won the special election held in December 1903 in a landslide. Lea became gravely ill in late January of the following year. Capt. Joseph C. Lea, the Father of Roswell, died February 4, 1904, and was laid to rest in South Side Cemetery. James F. Hinkle was voted the new mayor in the regular March election of that year. He can be seen, along with all the other city board members, in the very center of the 1905–1906 composite below. (Courtesy HSSNM, #354C, #879.)

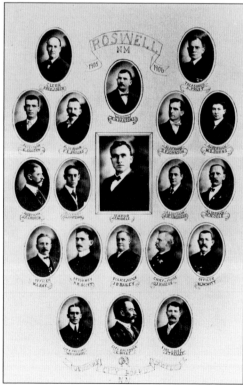

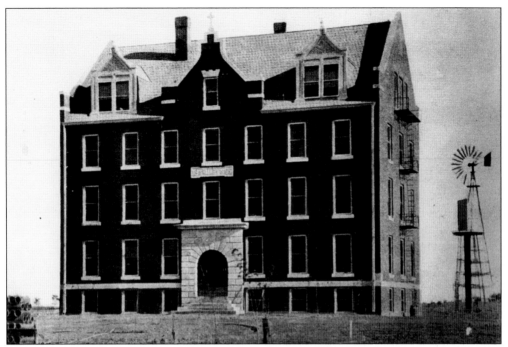

Sometime in 1906, St. Mary's Hospital, Roswell's first, was built. The hospital was built by the Sisters of the Sorrowful Mother, headed by Rev. Mother Boniface, for a cost of $20,000. Mother Boniface had come to Roswell in 1906 from Wisconsin to look into starting a hospital and sanitarium for the town. (Courtesy HSSNM, #188A.)

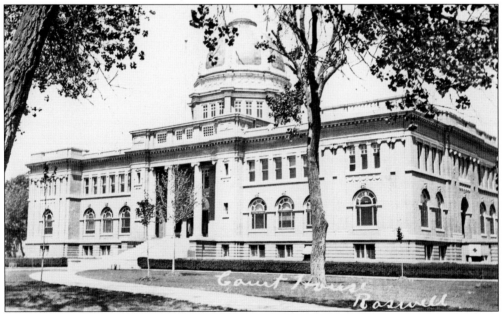

In 1910, New Mexico began the process to try to achieve statehood. In preparation for this, a new, much larger, Chaves County Courthouse was constructed in 1911. As can be seen here, it was one of the most beautiful buildings in New Mexico, which finally achieved statehood on January 6, 1912. (Courtesy HSSNM, #482B.)

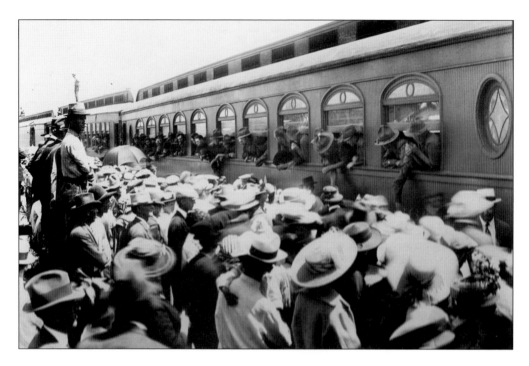

Many men from Roswell and Chaves County served in World War I as part of Battery A. Of Battery A's 296 men, 235 of them saw action in the war. Amazingly during this time Battery A only lost two men, and only another 12 men were wounded. Roland Oliver, an ex-sergeant of Battery A, was asked why he thought the men had such a low casualty rate; he answered, "We were a well trained outfit. The 'Old Man' saw to that, and then we were lucky that we never 'bracketed.'" The above photograph shows the men leaving Roswell to go to war in 1917. The photograph below shows Battery A in Columbus, New Mexico, after Poncho Villa's raid on March 6, 1916. (Courtesy HSSNM, #3948, #2674C.)

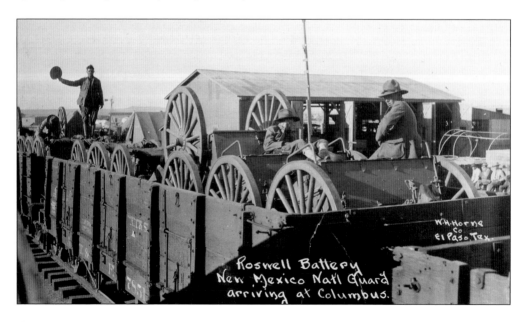

Four

ROBERT H. GODDARD AND THE 1930s

Like many cities in America during the Great Depression of the 1930s, Roswell hit upon some hard times. Roswell's great artesian wells that had brought so much growth and prosperity to the area had begun to dry up as early as 1916. The North and South Spring Rivers had also dried up by the early 1920s.

By the 1930s, due to several factors, Roswell's beautiful apple orchards would also be a thing of the past. Apple growers in Washington were producing better fruit, and spraying costs for insects made for additional expenses. The final nail in the coffin was the big freeze that occurred on the morning of February 8, 1933. The temperature dropped to 24 degrees below zero, killing many trees, and within a short time, Roswell's oasis-like appearance would only be a memory.

However, despite all the hardships, Roswell's population continued to grow rather than decline. Thanks to Pres. Franklin D. Roosevelt's New Deal programs, which promised jobs to needy citizens, many facets of modern-day Roswell were born. Workers from the Works Progress Administration (WPA) built several schools, Bitter Lake National Wildlife Refuge, a city hall, DeBremond Stadium, and Roswell's first museum in 1937, today known as the Roswell Museum and Art Center. The Civilian Conservation Corps (CCC) built New Mexico's first state park, Bottomless Lakes State Park, outside of Roswell in 1933.

The 1930s was also the era in which Roswell would play host to Dr. Robert H. Goddard, whose rocket launches north of town would have far-reaching and historic effects on the world and its future.

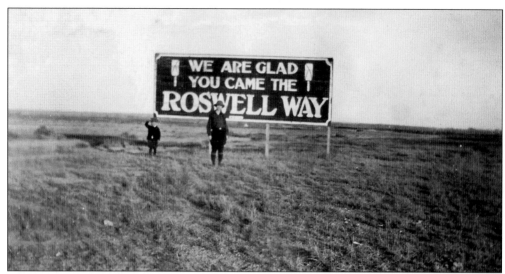

Visitors entering Roswell in the 1920s were greeted by this billboard proclaiming, "We are glad you came the Roswell way." By 1920, Roswell's population was solidly at 7,033 people, and by 1930 would grow to 11,173. (Courtesy HSSNM, #925B.)

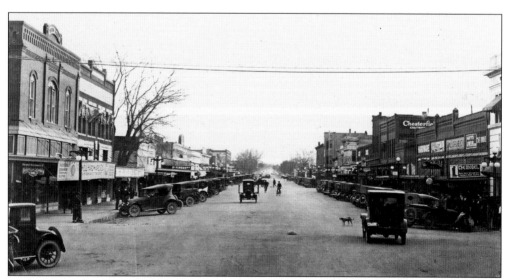

By the 1920s, the day of the horse and carriage was officially over, and the day of the automobile was in full swing. This photograph shows Roswell's bustling Main Street. Note the dog—did he get out of the way of that car in time?—and the bicyclers down the middle of the street. (Courtesy HSSNM, #572.)

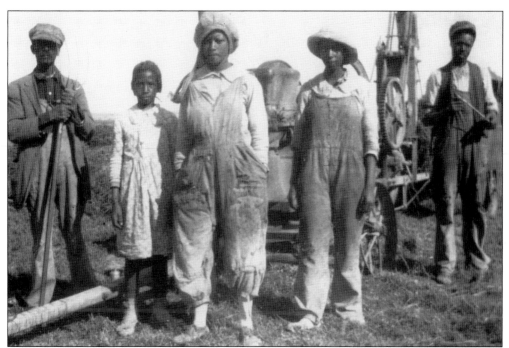

Due to the unfortunate segregation of the times, few African Americans lived in Roswell during the start of the 20th century. They instead bravely chose to start their own settlement about 15 miles south of town called Blackdom, New Mexico. Blackdom was settled in 1901, soon thrived with many African Americans, and was officially established as a township in 1920. However, due to the harsh droughts of the times, the town was abandoned by 1930. The photograph above shows, from left to right, Loney K. Wagoner, the three daughters of Joseph and Harriet Smith, and another unknown man. In the photograph below, Wagoner stands in front of his schoolhouse with several children. The schoolhouse also served as Blackdom's church. Today a historical marker stands near the former township. (Both courtesy HSSNM.)

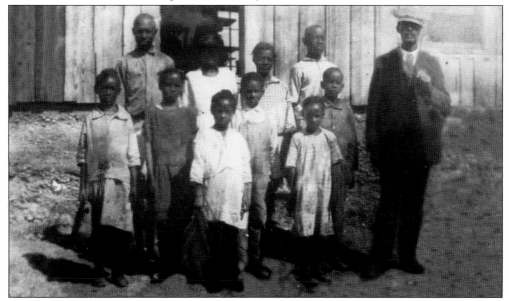

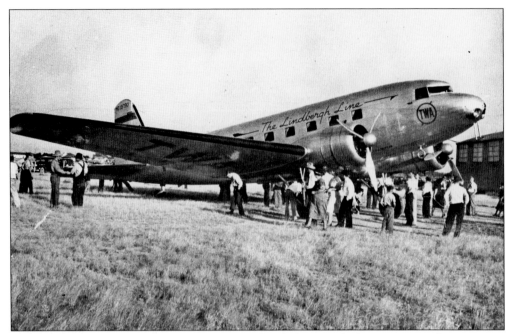

Roswell's first airport was built in 1929. This undated photograph shows town residents turning out in great fanfare to greet this plane from Trans Western Airlines carrying the moniker "The Lindbergh Line" to capitalize on the fame of its adviser, Charles Lindbergh. (Courtesy HSSNM, #2939.)

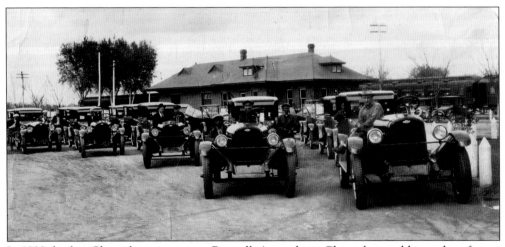

In 1928 the first Chevrolet cars came to Roswell. A year later, Chevrolet would introduce for use in commercial vehicles its new six-cylinder engine, nicknamed "the cast iron wonder" because of its intense durability. (Courtesy HSSN, #1747H.)

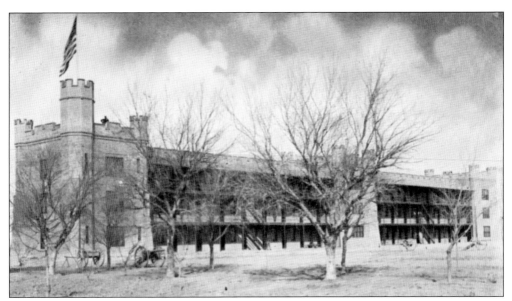

New Mexico Military Institute had continued to see exponential growth in the years since its founding. In 1909, NMMI was officially classified as a Distinguished Military School, and many new buildings were added, including the Hagerman Barracks, Wilson Hall, Cahoon Armory, and Pearson Auditorium, which was built in 1940. This postcard displays the "new barracks" at NMMI, which cost $60,000 to build. (Courtesy HSSNM, #2734A.)

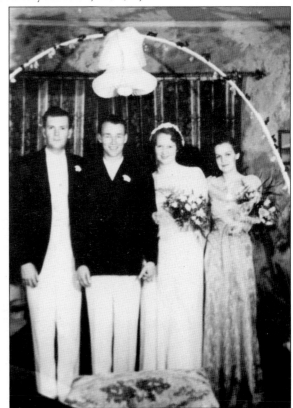

Famous western singer and film star Roy Rogers occasionally came to Roswell, and in 1933, he met his future wife, Arline Wilkins. Rogers and Wilkins were married on June 11, 1936, in the Wilkins family home. The bride and groom stand between Arline's brother and his wife in this photograph taken on their wedding day. Arline then moved with Rogers to Hollywood. (Courtesy HSSNM, #3166.)

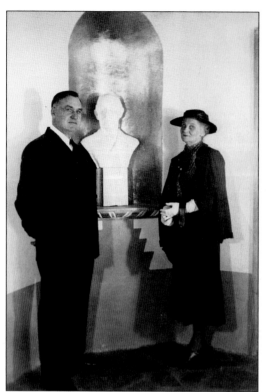

Lt. Gov. Hiram M. Dow stands with his wife, Ella Lea Bedell Dow, in front of a bust of her father, Capt. Joseph C. Lea, at the newly opened Roswell Museum. Also in the museum, which opened October 6, 1937, were busts of John Chisum, J. J. Hagerman, and Amelia Church. (Courtesy HSSNM, #2133A.)

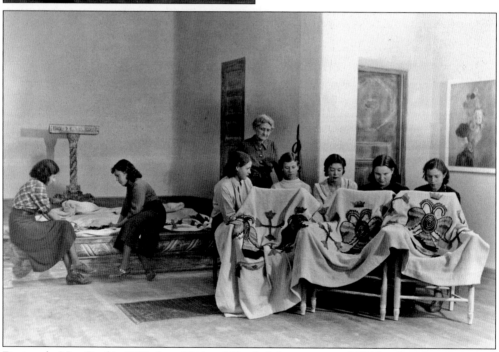

During the New Deal in 1937, these National Youth Administration (NYA) girls embroider a stage curtain for the Roswell Museum while their instructor, Amelia B. Martinez, looks on. (Roswell Museum and Art Center photograph, courtesy Museum of New Mexico Photo Archives, #90206.)

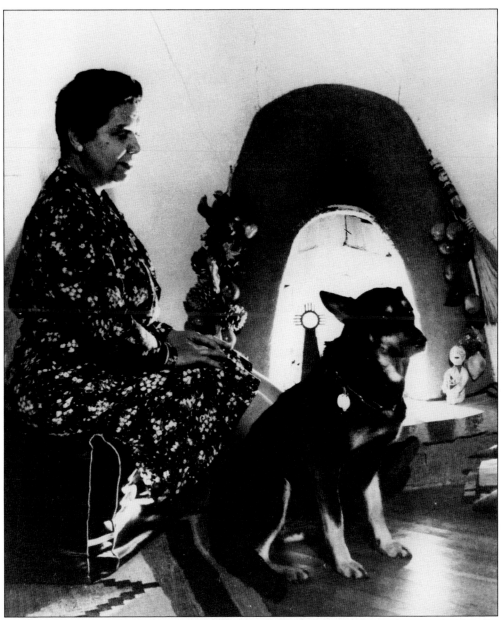

Elizabeth Garrett and her beloved Seeing Eye dog, Teene, are pictured in a photograph taken for a Christmas card in her "La Casita" home in Roswell. Elizabeth Garrett was the third of eight children born to Sheriff Pat Garrett and his wife, Apolinaria Gutierrez Garrett. Elizabeth was born October 12, 1885, and was discovered to be blind soon thereafter. Despite her disability, Elizabeth grew up to be a nationally recognized singer, songwriter, and teacher known as the "Songbird of the Southwest." She even performed in illustrious theaters in Chicago and New York. In 1917, she sung her composition, "O, Fair New Mexico," written a few years prior, to the New Mexico Legislature, which quickly and unanimously voted to make "O, Fair New Mexico" the official state song. Elizabeth Garrett called Roswell home for many years and died on the night of October 16, 1947, while walking home with her Seeing Eye dog during a blackout in the town. (Courtesy HSSNM, #3236.)

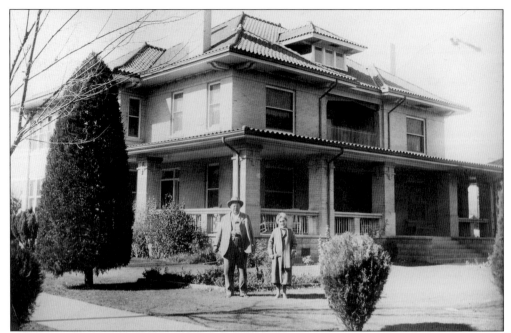

Shown here is Roswell's most famous residence, the home of J. P. and Lou White. The White family lived in the house for 60 years, from 1912 until 1972, after both Mr. and Mrs. White, shown here standing in front of the house, had passed away. The house later became the museum and center of operations for the Historical Center for Southeast New Mexico. (Courtesy HSSNM, #3083B.)

Lou Tomlinson and J. P. White were married in 1903. Their elegant home was constructed for them by Lou's father, D. Y. Tomlinson, a local contractor some of whose work is still standing in Roswell today, in 1912. Lou Tomlinson White is the third woman from the left in the front row in this photograph of the Roswell Woman's Club taken on the front steps of the White home. (Courtesy HSSNM, #1803A.)

J. P. White was born in Gonzalez, Texas, in 1856 and came to the Pecos Valley driving a herd of cattle in 1881 with his uncle, George Littlefield. Years later, in 1899, he met his future wife, Lou Tomlinson, at the Roswell Post Office. White is shown later in life as a businessman here. (Courtesy HSSNM, #3359.)

J. P. White purchased what was once called the Allison building in Roswell and added an additional three stories to it. The building still stands in Roswell and is called the J. P. White building. White's business interests, under the header J. P. White Industries, continued to thrive even after his death in 1934. The Allison building is shown here before it was bought by White. (Courtesy HSSNM, #480A.)

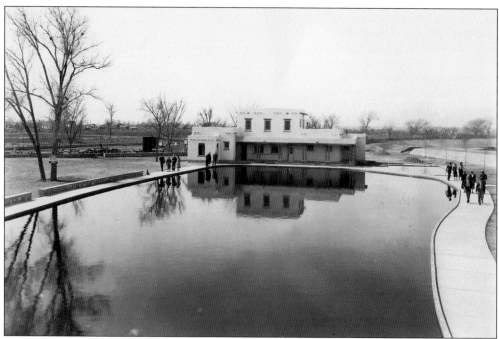

Shown here is the swimming pool (above) and sunken garden (below) in Cahoon Park. Cahoon Park began life as Hayne's Dream Park, which was established as far back as the 1890s. In 1935, people suggested the park, which was seeing new renovation thanks to the Works Progress Administration, be renamed Cahoon Park after E. A. Cahoon. It is even said that some of the stones used to build parts of the park were taken from the old Missouri Plaza corral. The park had its own swimming pool, a sunken garden, tennis courts, and picnic tables. In its early days, it even had a small zoo, complete with a lion. Many baby boomers growing up in the 1960s remember the lion's frightful roar. (Courtesy HSSNM, #2314, #4623.)

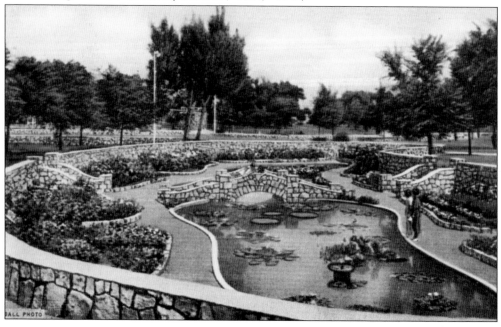

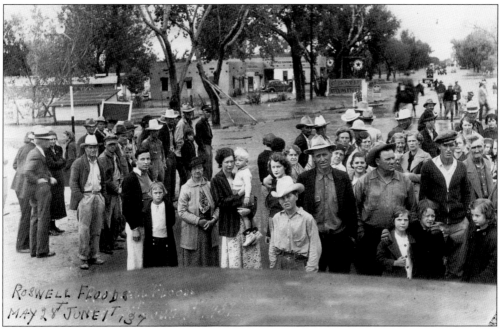

In the summer of 1937, Roswell was again subject to a rather devastating flood. A group of town residents can be seen above looking somewhat somber in the flood's aftermath. Carl Johnson, shown below, chose to lighten the mood during the flood by wading out into Main Street carrying a fishing pole. Perplexed residents watched in amazement as Johnson reeled out of the water a large carp. Unbeknownst to them, Johnson had secretly brought the fish with him in his waders and then hooked it onto his line under the secrecy of the water. (Courtesy HSSNM, #2788, #1757A.)

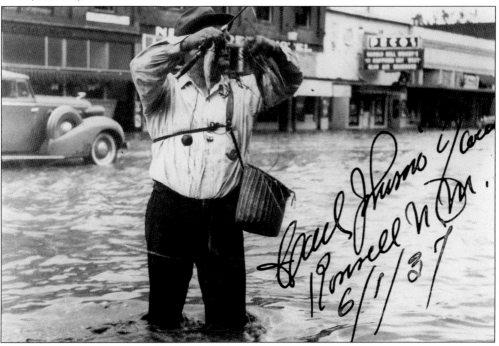

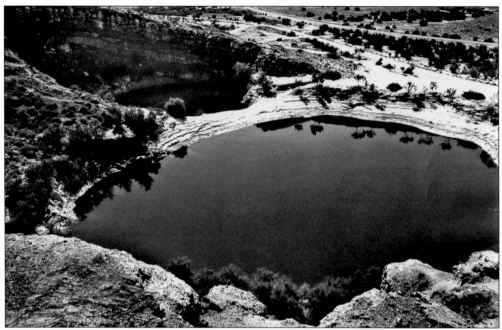

Shown above is Mirror Lake, one of nine lakes that make up Bottomless Lakes, which are in fact just massive sinkholes east of Roswell. They were named by cowboys traveling along the Goodnight-Loving Cattle Trail who used to drop their lariats in the sinkholes to determine their depth. When their lariats were swept away by underwater currents, one after another, the cowboys assumed that they were bottomless. In 1933, the area became New Mexico's very first state park when the Civilian Conservation Corps built a recreational area near the lakes. Swimmers are shown enjoying the water at Lea Lake, the main attraction and largest lake in the park, which is named after Capt. Joseph C. Lea (below). (Courtesy HSSNM, #293B, #5027.)

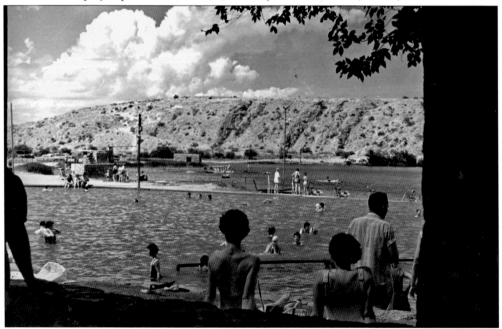

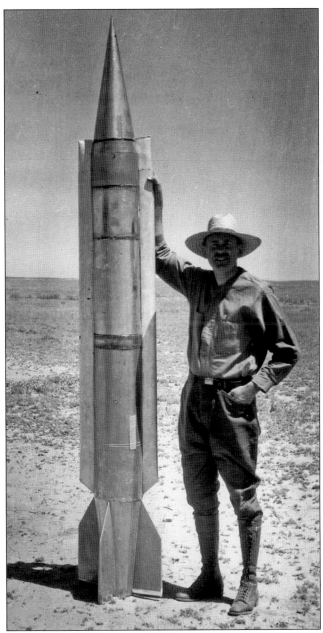

In the 1930s, Roswell received one of its most famous residents, Dr. Robert H. Goddard, now known as the father of modern rocketry, pictured here with one of his rockets outside of Roswell. Goddard was originally from Auburn, Massachusetts, where his rocket tests had been causing a bit of consternation among the locals, but had also caught the attention of famous aviator Charles Lindbergh. Lindbergh eventually set up funding for Goddard's tests from wealthy industrialist Daniel Guggenheim and suggested that Goddard move to Roswell in New Mexico. Because of Roswell's year-round outdoor working conditions, bright sunny skies, and a temperate climate, among other things, it was the ideal place for Goddard's rocket tests. Plus, most of the locals there kept out of his hair. Goddard and his wife, Esther, packed up their bags and left for Roswell, arriving there July 25, 1930. (NASA photograph, courtesy RMAC.)

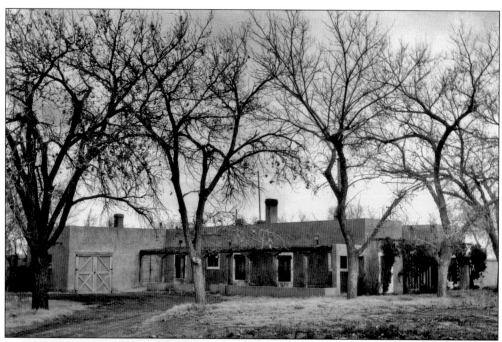

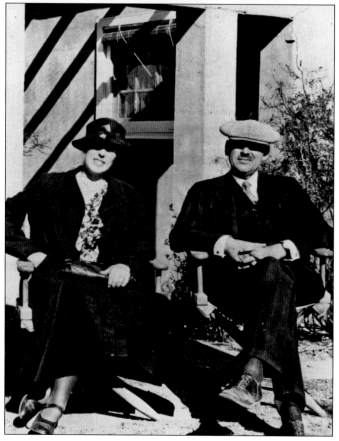

Upon arriving in Roswell, Dr. Robert H. Goddard and Esther began renting the home above, situated on the Mescalero Ranch three miles northeast of town. The house was owned by "Miss Effie" Olds, who had moved to Roswell during the big orchard boom in the early 1900s, although the Goddards would eventually buy it from her. They lived in the house from 1930 to 1932, briefly left Roswell, and then returned from 1934 until 1942, when Dr. Goddard received additional funding from Harry Guggenheim. Dr. Goddard and Esther are pictured sitting in front of their home in 1937. Photographs of the two together are rare, likely because Esther was often the one behind the camera. (NASA photographs, courtesy RMAC.)

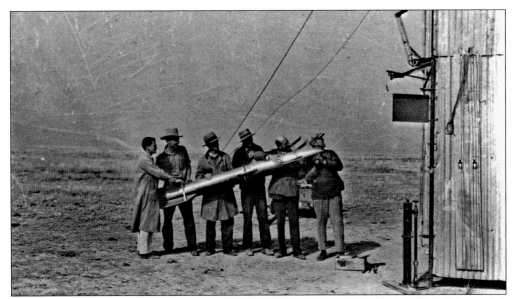

Dr. Robert H. Goddard (second from right) and some of his work crew, including (from left to right) Larry Mansur, Al Kisk, Charles Mansur, an unidentified man, and Ole Ljungquist, load an early rocket into the launch tower on October 17, 1931. All of Goddard's rocket tests took place in Eden Valley, 10 miles from the Mescalero Ranch in Roswell. (NASA photograph, courtesy RMAC.)

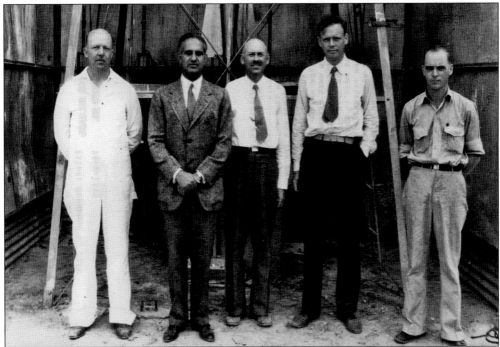

Charles Lindbergh often flew to Roswell to visit Dr. Robert H. Goddard. From left to right are Albert Kisk, Harry Guggenheim, Goddard, Lindbergh, and Ole Ljungquist in a photograph snapped by Esther Goddard on September 23, 1935. Ironically Guggenheim was never to witness one of Goddard's rocket launches. Lindbergh's yearly visits to Roswell always caused quite a stir among the town, much to Lindbergh's chagrin. (NASA photograph, courtesy RMAC.)

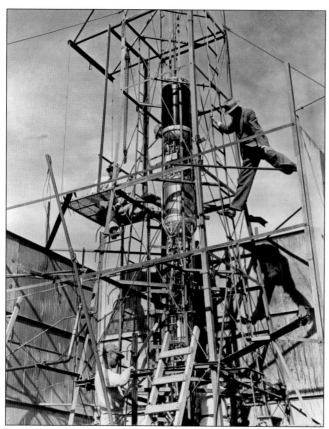

Dr. Robert H. Goddard, wearing a suit and hat while standing on the tower, supervises a rocket before the sheath and cap have been put on it in the launch tower. In the upper left is Mario Bustamente, in the center is Charles Mansur, and to the bottom left is Ole Ljungquist. (NASA photograph, courtesy of RMAC.)

Dr. Robert H. Goddard inspects the gauges connected to the pressure lines on the rocket in the launch tower with a telescope from his launch command post. When he saw that the readings on the gauges were right, he could operate the launch keys from the safety of his command post 1,000 feet away from the launch tower. (NASA photograph, courtesy RMAC.)

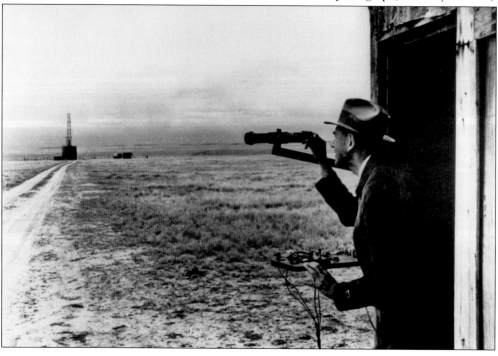

One of Dr. Robert H. Goddard's rockets is shown in flight on the night of August 26, 1937. In a 1938 rocket launch, one of his rockets flew 6,565 feet into the air. (NASA photograph, courtesy RMAC.)

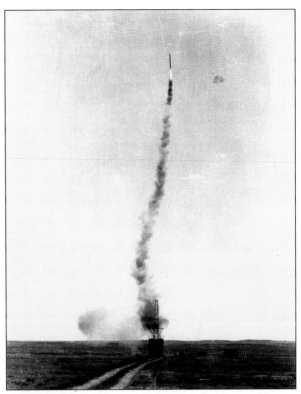

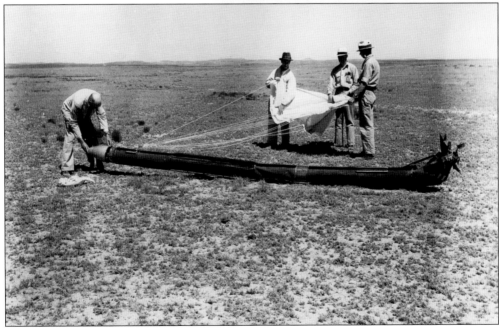

Everything that goes up must come down. Here Dr. Robert H. Goddard inspects a downed rocket at the crash site. A parachute was used to float the rocket back down to earth in hopes that it could be used again. The only major damage, according to the caption on the back of the photograph, appears to be "a damaged rear end and bent middle." (NASA photograph, courtesy RMAC.)

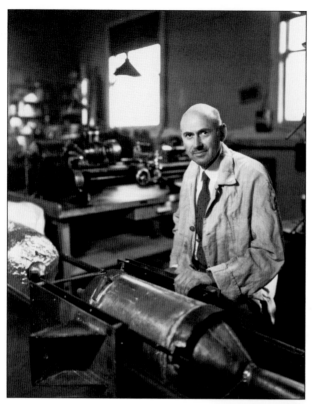

By the early 1940s, Dr. Robert H. Goddard, shown at left in his Mescalero workshop, left Roswell for Annapolis to do work on experimental aircraft for the U.S. Navy. Goddard died tragically of throat cancer in 1945, never being able to see for himself that his research would indeed pave the way for rockets to reach outer space and eventually the moon in 1969. In 1949, Esther Goddard donated Goddard's old launch tower to the Roswell Museum. From left to right below, Werner von Braun, Esther Goddard, and former NMMI superintendent Gen. Hugh Milton stand in front of the launch tower at the Roswell Museum on the day of the dedication of the museum's Goddard Wing, built with the help of Harry Guggenheim, in 1959. (Left, NASA photograph, courtesy RMAC; below, courtesy RMAC.)

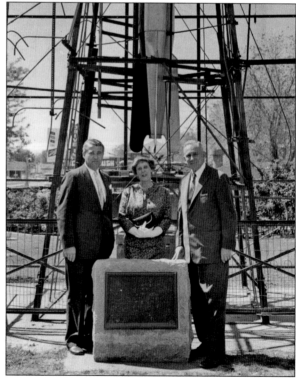

Five

WORLD WAR II
AND THE 1940s

The military began negotiations with the Roswell Chamber of Commerce (RCC) to build a military base in the town before the United States became involved in World War II with the bombing of Pearl Harbor on December 7, 1941. Army officials had met with Mayor Tom Hall, RCC president Claude Simpson, city manager Lee Rowland, and Ross Malone in June 1941 to look at a vacant stretch of land south of town as possible real estate to build upon. The army quickly decided it wanted a base in Roswell, and by September 1, 1941, construction began for what would first be called the Roswell Army Flying School. It was completed and operational by May 1942. The name was changed to the Roswell Army Air Field after a bombardier school was added as well.

Around the same time, a prisoner of war camp was built between Roswell and Dexter called Orchard Park POW Camp by many Roswellians, even though its official name was the Roswell Prisoner of War Internment Camp. The first German prisoners arrived on November 26, 1942, and another 4,000 would follow by August 1943. Ironically some of these POWs enjoyed Roswell so much that many of them wanted to stay and settle in the town or at least come back and visit.

The Roswell Army Air Field became one of the most prestigious bases of its kind after the end of World War II. This is because the RAAF became home to the 509th Bomb Group, the only atomic bomb unit in the world at the time.

Roswell accepted the base very enthusiastically and even threw a parade in its honor when it first came to town. The base ended up being a valuable asset in Roswell's growth and economy. The city's population tripled from the time the base arrived in the early 1940s to the 1960s.

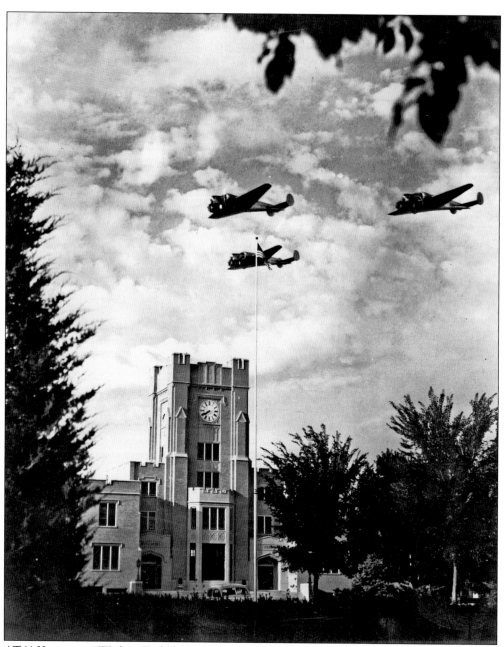

AT-11 Kansans—"Wichita Wobblers"—from the Roswell Army Air Field do a flyover above New Mexico Military Institute in this iconic photograph taken by renowned Roswell photographer Woodrow Jack Rodden in 1943. For bombardier training at the base, practice bombs with only three pounds of black powder were dropped so that the pilots could see a spark of light, determine how accurate their drop was, and keep noise down to a minimum so as not to bother nearby Roswellians. The practice bombs were dropped on small sheds as well as makeshift boats and buildings. Later a separate bombing range consisting of 960 acres was commissioned where high-explosive demolition bombs could be dropped. (Woodrow Jack Rodden Sr. Photograph, Courtesy HSSNM, #1796.)

The Roswell Army Air Field is shown in its early days in these two photographs taken on January 30, 1943. The water tower in the photograph at right, which has yet to be painted red and white, as it was during the base's prime, would become a very recognizable landmark at the RAAF. It still stands with its red and white colors at the Roswell International Air Center, which now occupies the former base. (Courtesy HSSNM, #2052M, #2052I.)

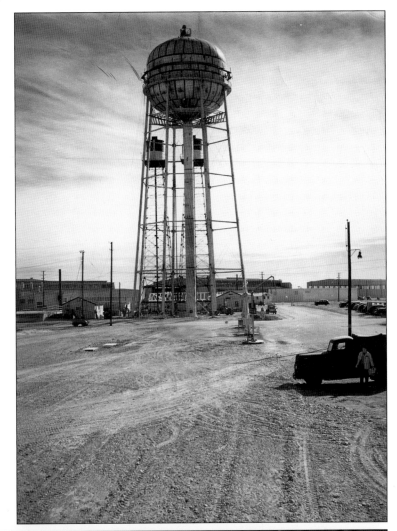

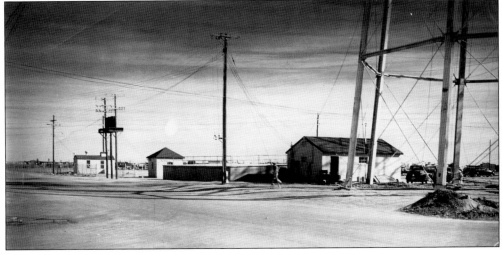

The Roswell base was meant to be a permanent installation when it was built to replace Moffett Field in California, which was being transferred to the U.S. Navy. The first three permanent buildings to be constructed on the base were the Sub-Depot warehouse, the Quartermaster Supply Building, and the Instrument Repair Building. (Courtesy HSSNM, #2889B.)

The main officer's club at the Roswell Army Airfield, shown here, was the site of many an interesting conversation. In 1947, mortician Glenn Dennis would meet here with a base nurse who drew him a sketch on a napkin of an alien body she had seen at the base hospital during the time of the Roswell incident. (Courtesy HSSNM, #976.)

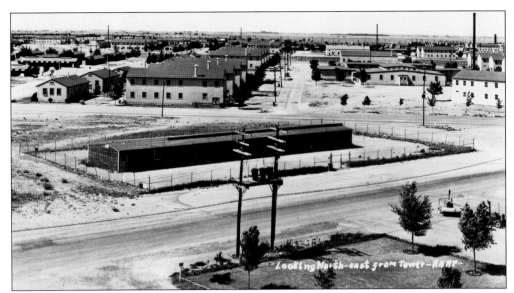

After the bombing of Pearl Harbor on December 7, 1941, construction at the base was sped up to make it operational as soon as possible. Instead of constructing permanent buildings made of brick and mortar, wood-frame buildings were constructed to save time and resources. (Courtesy HSSNM, #2889D.)

Due to the military's segregation at the time, African American servicemen had their own service club separate from the others. The African American service club is shown here in a photograph taken on June 7, 1944. (Courtesy HSSNM, #980.)

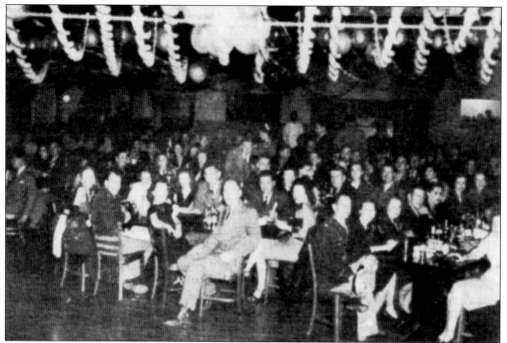

These photographs taken from the 1947 RAAF Yearbook show that the officers on the base did not have an "all work and no play" attitude. The photograph above is labeled "Party Time" in the yearbook and shows a gathering by the 1st Air Transport Unit (ATU), which functioned as a combat cargo squadron. The unit was eventually nicknamed Green Hornet Airlines, hence they are gathered in the "Hornet's Nest" for the party in the aforementioned photograph. In the picture below, men from the ATU are shown—"ditching practice," according to the RAAF Yearbook caption—going for a swim in the base pool. (RAAF Yearbook photographs, courtesy HSSNM.)

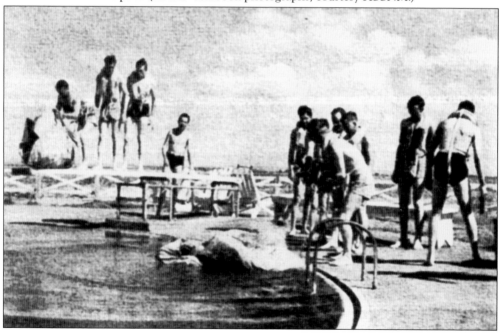

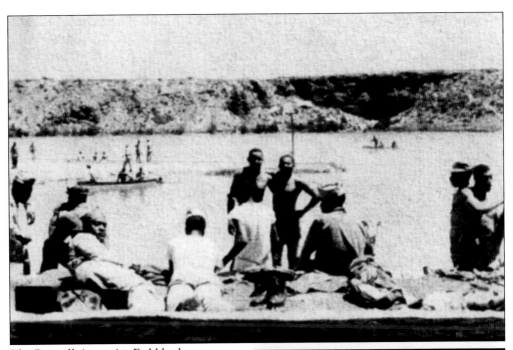

The Roswell Army Air Field had a segregated squadron of African American officers called Squadron S. Members from Squadron S can be seen relaxing at Bottomless Lakes State Park—notice Lea Lake in the background. (RAAF Yearbook photograph, courtesy HSSNM.)

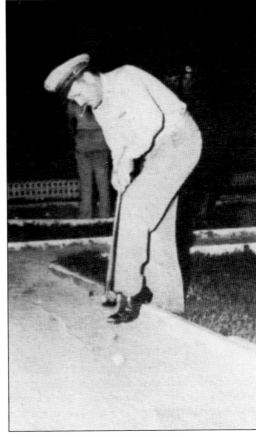

The future mastermind behind the 1947 Roswell incident weather balloon cover-up, Brig. Gen. Roger Ramey, putts his ball across the Roswell Army Air Field's miniature golf course. (RAAF Yearbook photograph, courtesy HSSNM.)

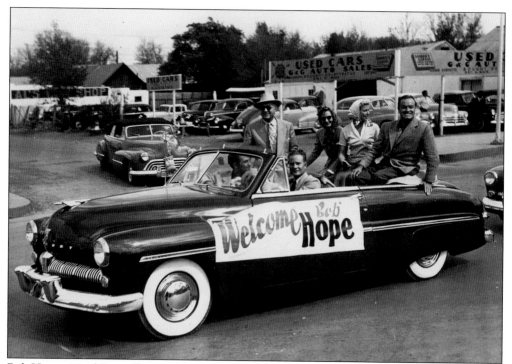

Bob Hope visited Roswell several times to entertain the officers at the Roswell Army Air Field. Roswell threw a parade in Hope's honor, as seen in the photograph above that shows Hope riding in a 1949 Mercury. Hope had previously been to town in 1943 as well. (Courtesy HSSNM, #1871B.)

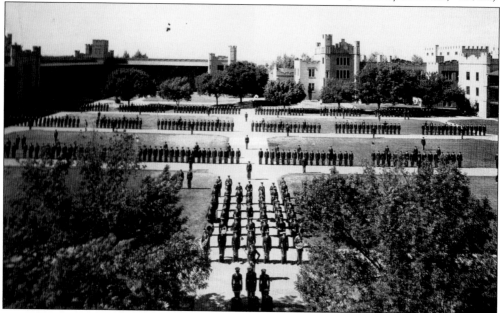

New Mexico Military Institute had many graduates who went on to become soldiers in World War II and many other conflicts. It was made a four-year college from 1948 up until March 1955, when it went back to being a four-year high school and two-year junior college. (Courtesy HSSNM, #165L.)

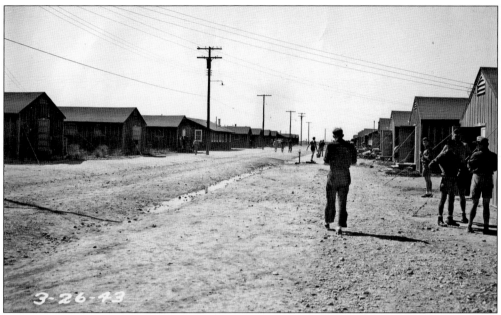

The Roswell Prisoner of War Internment Camp was one of the largest detention centers of its kind in the United States during World War II and encompassed 120 acres. The camp was surrounded by barbed wire fences and nearly a dozen guard towers. Escape attempts were rare, although the guards did once find a tunnel dug by the prisoners and filled it back in. The camp housed 4,800 prisoners, with three main compounds housing 1,600 POWs each. The camp also had four doctors, two dentists, seven nurses, and an optician in a 250-bed hospital. These two photographs display the barracks in 1943. Notice the croquet court and desert landscaping, done by the prisoners, in the bottom photograph. (Courtesy HSSNM, #1097, #1096.)

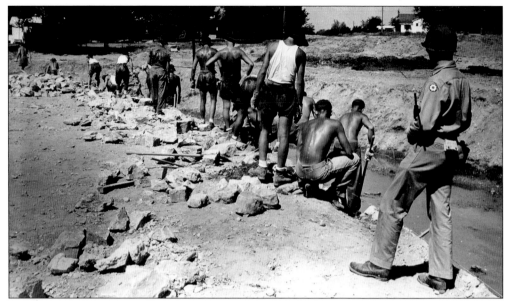

German POWs were put to work in 1943. Due to a labor shortage in the area, they were loaned out to various farms in the Pecos Valley. Most of them picked cotton, which they did not enjoy nor were they very productive at. Some of the POWs established good relationships with the farmers they worked for, and near the end of the war, after V-E Day, some prisoners were allowed to work on the farms without guards. The most recognizable work the POWs did in Roswell was the riprapping of the banks of North Spring River with stone as a way to prevent erosion caused by rainwater and flooding. The German prisoners are shown hard at work on North Spring River in these two photographs. (Courtesy HSSNM, #1093C, #1094.)

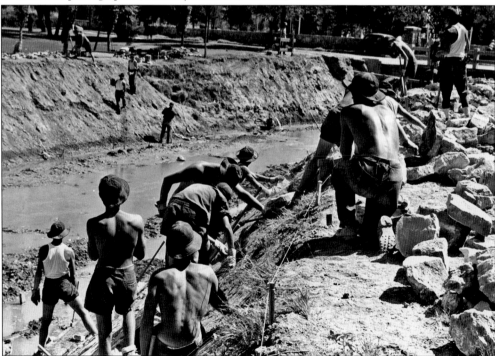

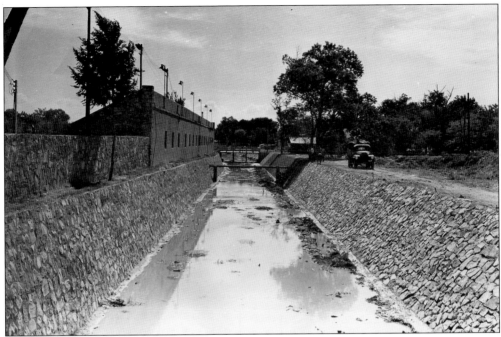

The finished North Spring River can be seen in the photograph above. Of the 50 German POWs chosen to do the work, some were die-hard Nazis who chose rocks of various shapes, colors, and sizes, to inlay their emblem, the Iron Cross, in the river. The cross, located between Kentucky and Pennsylvania Avenues in Roswell and pictured below, was covered with concrete when discovered by the locals. Nearly 40 years later, when the concrete was chipped away and the Iron Cross resurfaced, residents decided to leave it as a historical marker. (Courtesy HSSNM, #1095, #1274.)

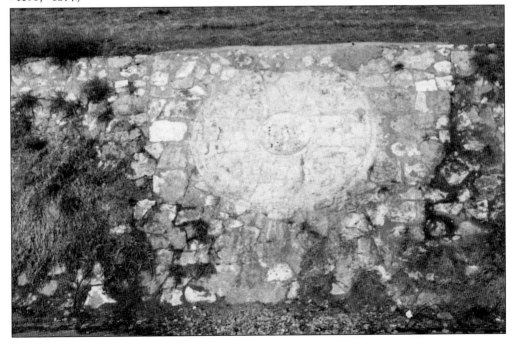

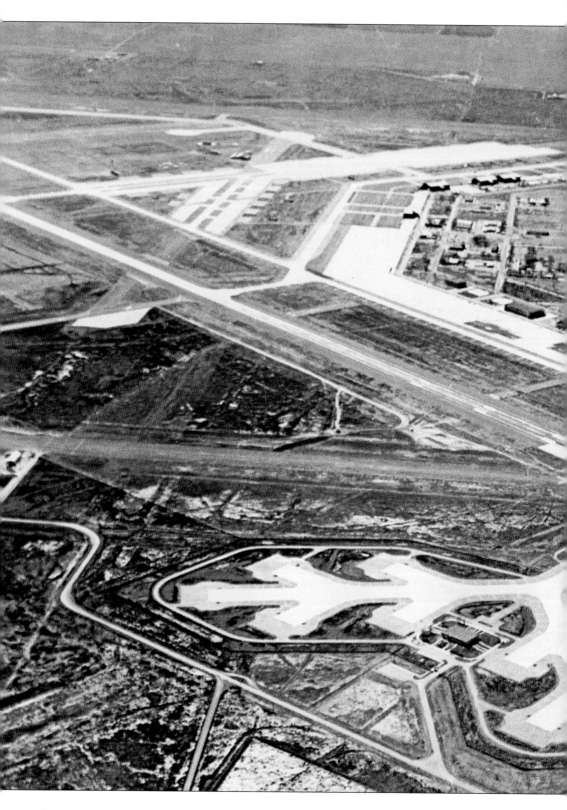

After the war in the Pacific theater was over and the atomic bombs had been dropped on Hiroshima and Nagasaki, the elite unit that had dropped them, the 509th Bomb Group, came to Roswell. Security was high at the base and use of deadly force was authorized. Reportedly it was used at least once, when an airman ran across a restricted area and failed to yield to the guard's warnings. The planes sat on the runways visible near the bottom half of this photograph. The base had a total of seven runways, and the longest was 11,500 feet. During the climax of the Cuban missile crisis of 1962, B-52s allegedly sat on the runways with engines running and ready to take off at a moment's notice. (Courtesy HSSNM, #877.)

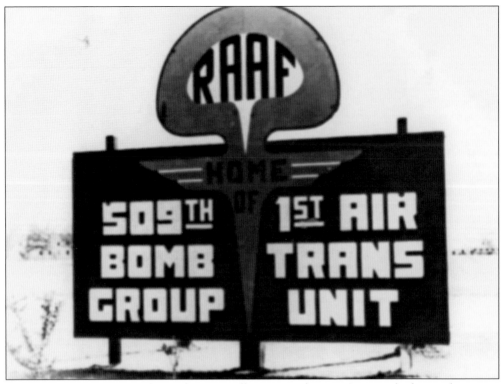

The 509th Bomb Group relocated to Roswell in November 1945 primarily due to the town's secluded location, which gave it added security from spies. Armed guards walked the base's perimeter day and night to ensure tight security. This sign on the base proudly displayed the 509th Bomb Group's presence. (Courtesy HSSNM, #4611.)

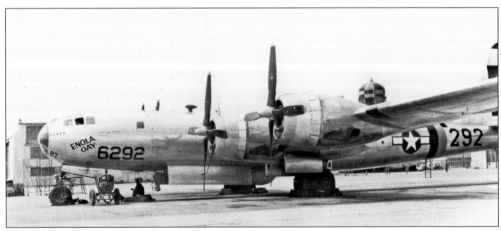

The Enola Gay, which dropped the atomic bomb on Hiroshima, briefly occupied a spot on the RAAF runway after the war until it was decided that, due to the aircraft's historic nature, it should be preserved and put out of commission. It is seen resting here on the RAAF runway. (Courtesy HSSNM, #2654A.)

Six

THE ROSWELL INCIDENT

On the morning of July 6, 1947, something happened in Roswell, New Mexico, that changed the city forever. Sheep rancher William W. "Mack" Brazel had just driven into Roswell to see the sheriff, George Wilcox, about strange debris he had found 75 miles north of town near Corona, New Mexico, on the J. B. Foster ranch, of which Brazel was foreman. Sheriff Wilcox soon received a phone call from Frank Joyce of the local KGFL radio station looking for interesting news to liven up an otherwise boring day. Wilcox handed the phone to Brazel so he could tell his story of stumbling across some strange wreckage and even stranger bodies to Joyce, who suggested to Brazel that they call the Roswell Army Air Field.

After the airbase received the call, Maj. Jesse A. Marcel, the base's chief intelligence officer, went to see Brazel over at the sheriff's office. Both impressed and perplexed by the debris samples Brazel had brought into town with him, Marcel contacted his commanding officer, Col. William H. "Butch" Blanchard, who instructed Marcel to go out to Brazel's ranch and investigate the debris, which they speculated could be from some sort of crash.

By the next day, Brazel, Marcel, and Capt. Sheridan Cavitt of the counterintelligence corps had inspected the ranch and found even more debris spread out over a radius equivalent to several football fields. Soon the RAAF made an extensive sweep of the area, collecting the wreckage and taking it back to the airbase in Roswell.

On July 8, 1947, the *Roswell Daily Record* broke the story with the headline, "RAAF Captures Flying Saucer on Ranch in Roswell Region." After this, the events involving the crash would take on a dark and mysterious turn with talk of alien bodies, a space craft, and the lives of town residents being threatened by the government to keep quiet about it, or else.

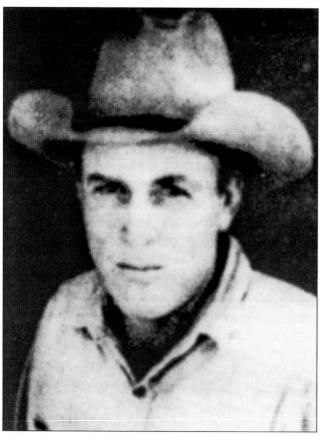

Shown at left, in a photograph taken by the *Roswell Daily Record*, is William Ware "Mack" Brazel, the rancher who found the crash debris at the Foster ranch on the plains of Corona (below). Before gaining recognition as the rancher who found the saucer debris, Mack was known for being a tough and honest cowhand. He was renowned for his habit of never killing a rattlesnake with a gun or a rock, but instead always preferring to "walk across them" and crush them with his boot heel. Mack was born in 1899 and was described as a throwback to the cowboys of the old days. He gained the nickname "Mack," according to his older sister, Lorraine Ferguson, because as a baby he resembled Pres. William McKinley. (At left, courtesy *Roswell Daily Record*; below, courtesy Dennis Balthaser.)

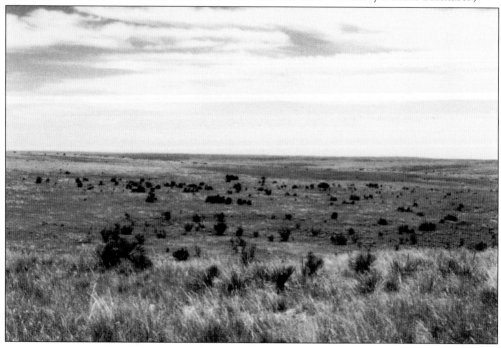

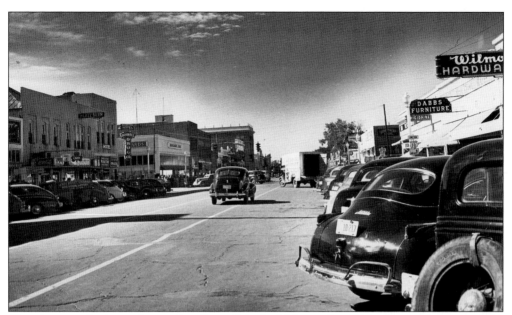

The photograph above shows what Roswell looked like in the 1940s, during the time of the crash. Shown below is Radio Station KGFL, where Frank Joyce was working the day he called Sheriff Wilcox's office to talk to Mack Brazel about the wreckage on the Foster ranch and the strange bodies Brazel found at another location. Later on, when the military was trying to cover up the evidence of the crash, Brazel would meet with Joyce in a government-orchestrated meeting to tell Joyce to keep quiet about what he had told him and that their lives would never be the same again, according to Joyce during an interview with Tom Carey and Don Schmitt in 1998. (Courtesy HSSNM, #159J, #1259.)

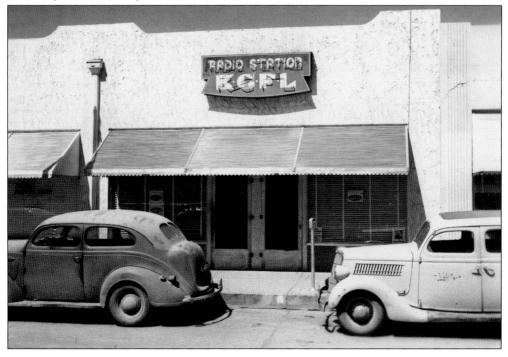

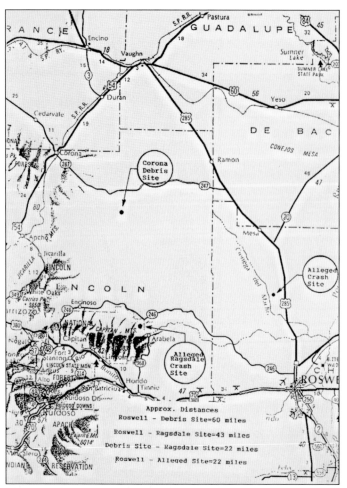

This map, made by Dennis Balthaser, shows the location of the Corona debris field and two other alleged crash sites (the Ragsdale site is believed to be false). Most ufologists now concur that the alien craft was possibly struck by lightning over the Foster ranch, raining debris on the ground below, while the craft itself and its alien occupants continued southeast, landing elsewhere closer to Roswell. (Courtesy Dennis Balthaser.)

When Maj. Jesse A. Marcel and Capt. Sheridan Cavitt arrived on the Foster sheep ranch with Mack Brazel, it was too late to go out and look at the debris, so they had to spend the night in the small ranch house pictured here. Marcel reminisced in an interview that all they had to eat was some cold pork and beans and crackers. (Courtesy Dennis Balthaser.)

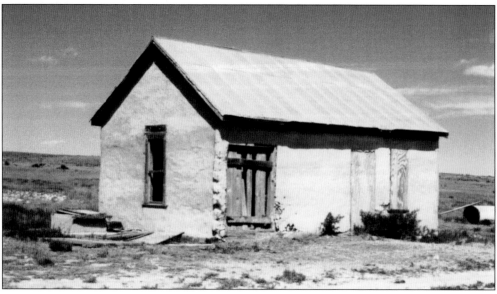

This image shows an alleged flying saucer photographed in Passoria, New Jersey, in 1952. Considering that only a small portion of the Roswell crash was said to be recovered intact, it is open to debate what the complete craft looked like for certain. It is believed that what was recovered at the impact site was possibly a cockpit or escape pod. (Courtesy CIA.)

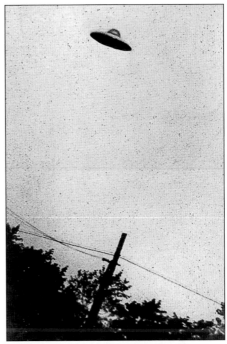

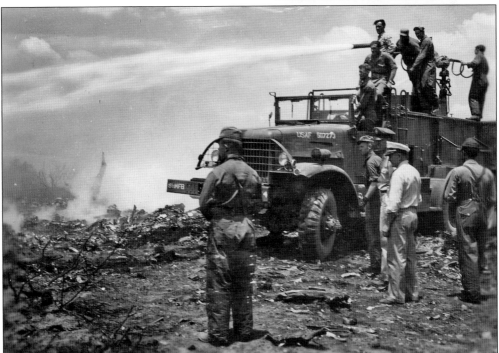

The RAAF spent a number of days cleaning up the debris at the Foster ranch and the impact site and taking it back to the base. Since no declassified photographs exist of either the impact site or the debris field, this image of RAAF firefighters attending to the wreckage of a downed plane probably best represents what the activity at the sites would have looked like to some degree. (Courtesy HSSNM, #2052T.)

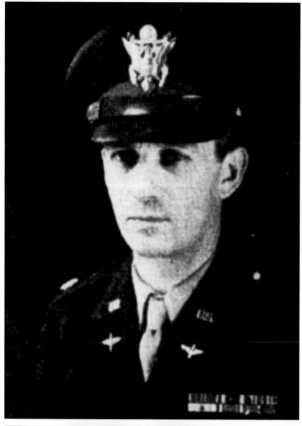

Maj. Jesse A. Marcel is shown in this photograph taken for the RAAF Yearbook. Major Marcel took some of the crash debris back to the RAAF in the back of a carryall trailer hauled by his 1942 Buick. Before Marcel went to the base, though, he stopped by his home, pictured below, early in the morning hours of Tuesday, July 8, to show his wife and son, Jesse Jr., some of the strange debris from the ranch. Marcel spread the debris out on the kitchen table and floor. Jesse Marcel Jr. specifically recalls, as do many other witnesses, strange I-beams with hieroglyphic-type writing on them. Other witnesses also recall a type of "memory foil," that when crumpled up or folded would return to its original shape. (At left, 1947 RAAF Yearbook photograph, courtesy HSSNM; below, courtesy Dennis Balthaser.)

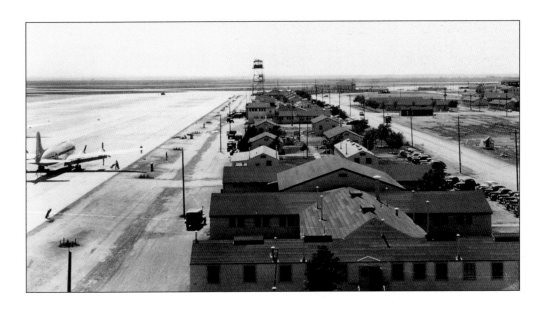

Unlike the calm photograph above, during the days and nights of the crash recovery, the Roswell Army Air Field was in a frenzy of activity, with many mysterious planes flying in and out of the base. The wreckage from the crash, as well as some of the alien bodies, was taken to Hangar No. P-3, shown below. Witnesses recall seeing a jeep convoy escorting a truck hauling part of the craft, covered by a tarp, on a large flatbed trailer through Roswell. Ironically, according to the book *Witness to Roswell*, one witness was a paperboy delivering the famous issue of the *Roswell Daily Record* announcing the crash. Hangar No. P-3 would remain under heavily armed guard while it harbored both the wreckage and the alien bodies from the crash. The hangar still stands and today is called Hangar No. 84. (Courtesy HSSNM, #2889C, #2889A.)

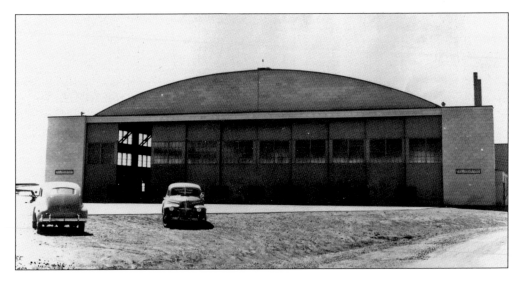

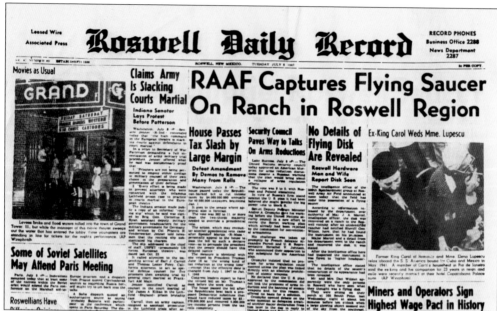

On Tuesday, July 8, the story broke that the Roswell Army Air Field had captured a flying disc on a ranch outside of Roswell. The press release was approved by the base commander, Col. William Blanchard, and delivered to the *Roswell Daily Record* in person by public information officer 1st Lt. Walter Haut. The *Roswell Daily Record* was delivered that afternoon, confirming rumors that had abounded around Roswell (below) the previous day of the crashed flying saucer and the "little men" that accompanied it. It is still open to debate whether the press release was a mistake on Blanchard's part or intentional. Some researchers suspect news of the debris field was leaked so as to divert attention away from the actual impact site closer to Roswell. (Above, courtesy the *Roswell Daily Record*; below, courtesy HSSNM, #1583.)

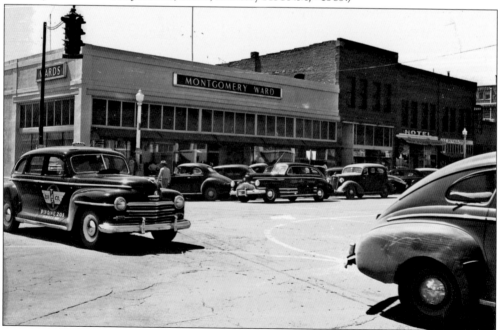

Not long after the RAAF's press release about the recovery of a crashed disc, the story was retracted and the infamous cover-up began. Brig. Gen. Roger Ramey, Col. William Blanchard's superior in Fort Worth, Texas, issued a new press release that the flying disc was actually a weather balloon. General Ramey (left) and Colonel Blanchard (right) can be seen conversing in the photograph at right prior to the events of the Roswell incident in 1947. On July 9, 1947, the *Roswell Daily Record* ran the headline seen below, denouncing the saucer story. The man in the front-page photograph is Sheriff George Wilcox, who became an unwilling pawn of the military to threaten town residents to keep quiet about what they had seen. (Right, 1947 RAAF Yearbook photograph, courtesy HSSNM; below, courtesy *Roswell Daily Record*.)

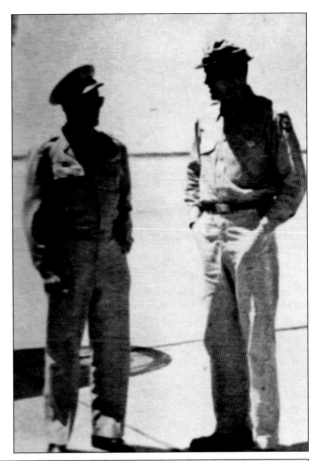

Roswell Daily Record

Leased Wire
Associated Press

RECORD PHONES
Business Office 2288
News Department 2287

Gen. Ramey Empties Roswell Saucer

Lewis Pushes Advantage in New Contract

Sheriff Wilcox Takes Leading Role in Excitement Over Report 'Saucer' Found

Arrest 2,000 In Athens in Commie Plot

Send First Roswell Wire Photos from Record Office

Ramey Says Excitement Is Not Justified

General Ramey Says Disk Is Weather Balloon

U. S. Lend-Lease To Britain Looms As Needed by Fall

Attorney to Force Closing up of

Local Weatherman Believes Disks Io Be Bureau Devices

Romania Rejects Bid to Take Part In Economic Meet

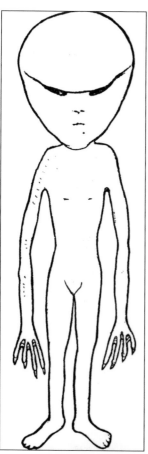

What caused the biggest shock at the airfield was the talk of several dead alien bodies, which were supposedly under constant heavy guard. Prominent ufologist Leonard Stringfield made this sketch in 1978 based upon descriptions given to him by several doctors who allegedly had performed autopsies on the bodies. (Courtesy estate of Leonard H. Stringfield, Ufologist.)

Among the alleged aliens found at the crash, at least one was rumored to still be alive. What exactly happened to the live alien is hard for investigators to conclude, but the dead bodies were said to have been flown to the Fort Worth Army Airfield on July 9 in the B-29 "Straight Flush," pictured below. (RAAF Yearbook photograph, courtesy HSSNM.)

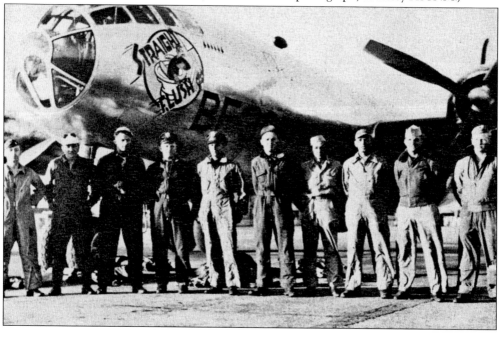

Mack Brazel was missing on the morning of Tuesday, July 9. He was eventually found in the home of Radio KGFL owner Walt Whitmore Sr., who had brought Brazel there the previous night to conduct an interview that would be broadcast the following day. The military confiscated the interview, and after that, they did not let Brazel out of their sight for the next seven days. For most of that time, Brazel would be kept at the base guest house (right), shown behind a Mr. and Mrs. Rodman Cookson in a photograph from 1946. The base guest house was located near the base's front gate (below). Brazel was finally released and able to return to the Foster ranch on July 15 the next week. (Both courtesy HSSNM, #3521.)

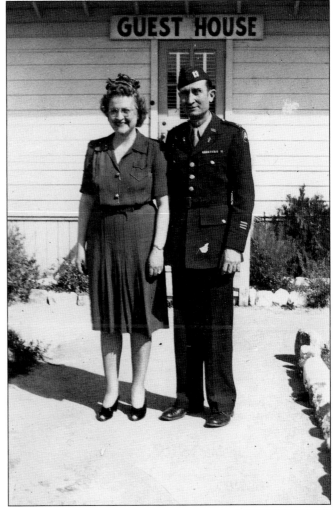

Pictured left and below respectively, in their RAAF Yearbook photographs are Col. William "Butch" Blanchard and public information officer 1st Lt. Walter Haut, the two men responsible for letting the world know about the crash of a flying saucer north of Roswell via the famous press release. Haut and Blanchard were very good friends, with a relationship similar to an uncle and his favorite nephew. Haut, who was one of the founding members of the International UFO Museum and Research Center, honored his promise to Blanchard to stay silent about what he knew about the crash and goings on at the base until Haut's death in 2005. (Both RAAF Yearbook photographs, courtesy HSSNM.)

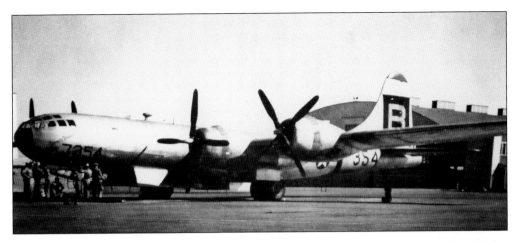

Pictured above is the B-29 "Dave's Dream," which flew Maj. Jesse A. Marcel and bits of the wreckage to Fort Worth Army Air Field to Brig. Gen. Roger Ramey for his inspection. Little did Marcel know that once he arrived in Fort Worth, the wreckage he had brought with him would be replaced by pieces of a weather balloon to enforce the infamous cover-up. In the photograph below, taken for the RAAF's newspaper, the *Atomic Blast*, some of the key players in the cover-up are pictured. From left to right are Col. William H. Blanchard, General Ramey, secretary of war Robert P. Patterson, Strategic Air Command (SAC) commander Gen. George Kenney, deputy SAC commander Clements McMullin, and retired World War I air hero Capt. Eddie Rickenbacker (who was not involved in the cover-up). (Both U.S. Air Force photographs, courtesy Tom Carey.)

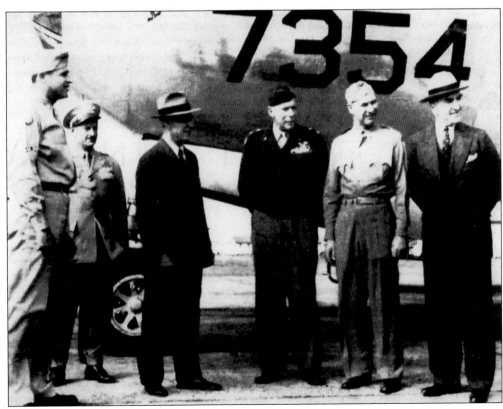

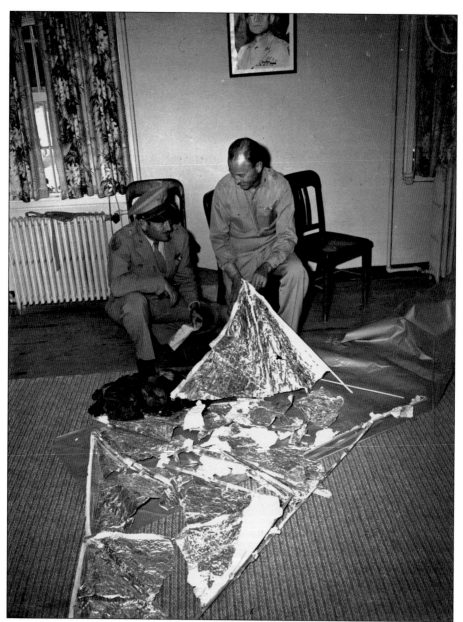

Brig. Gen. Roger Ramey and his chief of staff, Col. Thomas J. DuBose, pose with pieces of a weather balloon and a tinfoil radar target on July 8, 1947, in Ramey's office in Fort Worth. The note General Ramey is holding in his hand was later analyzed with computer technology by several individuals, notably James Bond Johnson and David Rudiak. After close scrutiny, it has been deduced that part of the note appears to read as follows: "The victims of the crash are being transported to Fort Worth. Urgent. Powers are needed at site two NW Roswell, N Mex." The note seems to confirm rumors of bodies. Little did Ramey know that as he posed with the pieces of a weather balloon in an attempt to cover up the truth he was in fact, in the opinion of most ufologists and Roswell believers, holding the "smoking gun" right in his hand. (Courtesy *Fort Worth Star-Telegram* Collection, Special Collections, the University of Texas at Arlington Library, Arlington, Texas.)

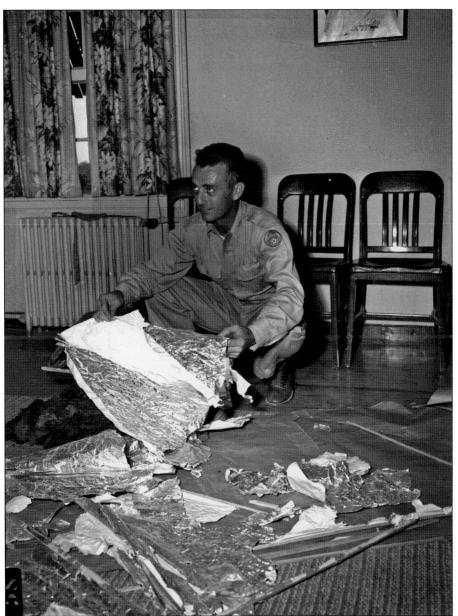

On July 8, 1947, in Brig. Gen. Roger Ramey's office at the Fort Worth Army Air Field, James Bond Johnson took this photograph and the accompanying photograph on the opposite page. Marcel had brought with him pieces of the real debris to show Ramey. Upon arriving in Ramey's office, Marcel set a package full with debris down and went with Ramey to the map room so that Marcel could show him exactly where the materials were discovered. Upon returning to Ramey's office, sprawled upon the floor were pieces of the weather balloon Marcel poses with here. Marcel, the Roswell Army Air Field's chief intelligence officer, was also instructed by Ramey not to speak to the press. Marcel returned to Roswell on Wednesday, July 9, via the B-29 "Straight Flush," which had arrived in Fort Worth to deliver the dead alien bodies to the Fort Worth Army Airfield, or so it is believed. (Courtesy *Fort Worth Star-Telegram* Collection, Special Collections, the University of Texas at Arlington Library, Arlington, Texas.)

To make sure that talk of the crashed saucer and alien bodies stayed covered up, the U.S. military swore their officers to secrecy on the matter. When it came to the civilians in Roswell though, the military threatened them to keep silent with their lives. This photograph shows officers of the Roswell Army Air Field marching in the town during a parade. (Courtesy HSSNM, #5634.)

Wade's Bar in Corona, shown here in later years under a different name, was the first place Mack Brazel told anyone about the debris he found in his field. Years later Brazel's son, Bill Brazel, was overheard one evening in Wade's Bar talking about some of the debris he had found and kept at his home. Military men were at his doorstep the next morning to retrieve it. (Courtesy Dennis Balthaser.)

In the 1990s, when an explosion of renewed interest in the Roswell incident emerged, the U.S. Air Force attempted to "come clean" on Roswell when they published *The Roswell Report* in July 1994. In the massive report the Air Force claims that the wreckage discovered was part of a top-secret high-altitude balloon research project code named Project Mogul. The top photograph, which accompanied the report, displays one such top-secret balloon-born experiment, with a disc-shaped aeroshell of a NASA Voyager-Mars space probe attached to a balloon prior to launch. The below photograph shows anthropomorphic crash-test dummies the U.S. Air Force says explains accounts of alien bodies being recovered in the wreckage. However, these crash test dummies were not in use by the U.S. military until 1953. (Both courtesy U.S. Air Force.)

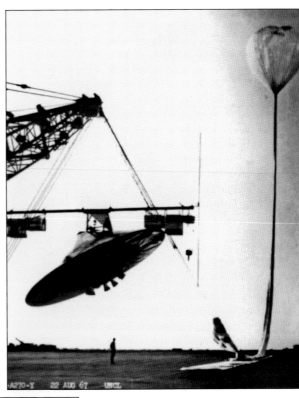

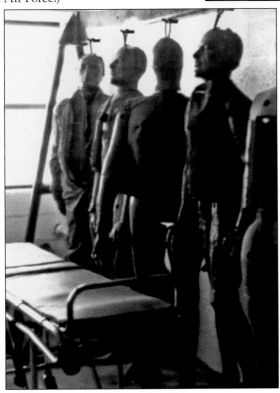

Mack Brazel and his family eventually moved to Albuquerque after the events of the Roswell incident. Mack kept silent about the incident for the remainder of his life and passed away in 1962 at the age of 63. He is shown here with his wife, Maggie, in 1951. (Courtesy Joe Brazel.)

These passersby do not know it, but as they walk past the Plains Theater they are also walking by the future home of the International UFO Museum and Research Center. The IUFOMRC has drawn in over one million visitors since its founding in 1991. It moved into the old Plains Theater on January 1, 1997. (Courtesy HSSNM, # 5693.)

Seven

CHANGING TIMES

After the July 9, 1947, *Roswell Daily Record* cleverly proclaimed the headline, "Gen. Ramey Empties Roswell Saucer," talk of the crashed UFO and little green men quickly faded away amongst the town and for the most part would remain that way until a resurgence of interest occurred on the subject many years later.

In the meantime, the Roswell Army Air Field went through another name change when the army split with the Air Force, and the base became the Roswell Air Field. That name did not stick long either, because in January 1948, the airfield was made a "permanent" base of the Strategic Air Command. The name was changed to Walker Air Force Base on January 13, 1948. It was named in honor of Gen. Kenneth Newton Walker of Los Cerrillos, New Mexico, who had died in the Pacific theater in 1942. Walker and his group of fighter pilots had led an attack on several Japanese ships. Walker disappeared; the last anyone saw of him was in his plane, with one engine on fire, being pursued by enemy fighters.

Now designated as a permanent installation, Walker Air Force Base (WAFB) would see more growth, and in turn, so would Roswell. Between 1950 and 1960, Roswell would gain another 13,000-some residents, jumping from a population of 25,738 people to that of 39,593 in 10 years.

In many ways, the 1950s and 1960s were Roswell's and the base's heyday. In 1960, WAFB was chosen as a support base for a unit of Atlas missiles, and by 1962 the $100 million project was in operation. However, this heyday would not last in Roswell forever, because as it turned out, the permanent SAC base at Walker was not so permanent after all, and its closure would prove to be a nearly devastating blow to the town in the late 1960s.

This picture by photographer Tony Redmon shows the Roswell of the late 1940s and early 1950s that many baby boomers so fondly remember, as an officer from the base steps off of the corner of 126 North Main Street and away from Roswell Drug Company. (Courtesy HSSNM, #5692.)

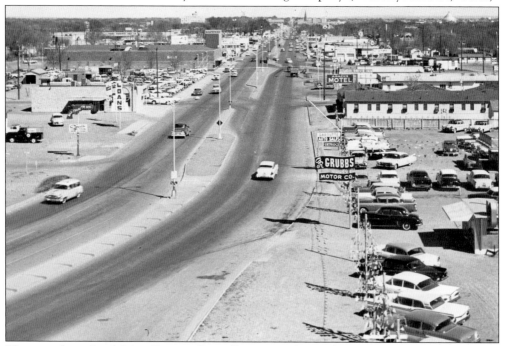

This view shows South Main Street in Roswell sometime during the 1960s. Among the discernible businesses pictured on the right-hand side are Grubb's Motor Company, Apache Motel, Willie's Drive-In, and on the left, Quality Liquor, Safeway Grocery Store, and Broadmoor Shopping Center. (Courtesy HSSNM, #1693.)

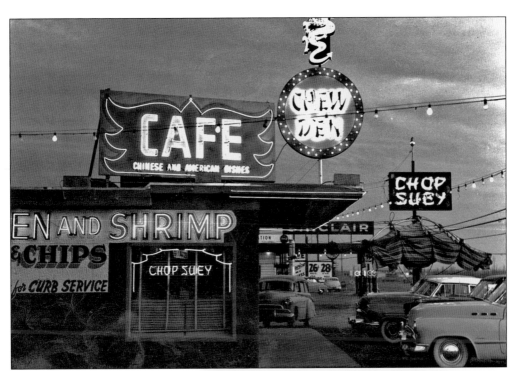

One of the most popular restaurants in Roswell during this time period was Chew Den, owned and operated by Jack and Suzie Chew. One night, Jack and members of the Elks Club were arrested for gambling in the kitchen after-hours by the Roswell Police Department. Today the Chews operate Chew's Oriental Gifts and Coins next to Chew's West, a restaurant opened in 1990, on West Second Street. (Courtesy HSSNM, #4061.)

The Yucca Theater on West Third Street was a popular place for Roswell schoolchildren to see motion pictures, since the theater offered a discount for students with good grades. Although this theater was smaller than some of the others in town, it was nicely furnished, complete with a balcony. (Courtesy HSSNM, #5694.)

One of the more colorful characters to inhabit Roswell in the 1930s, 1940s, and 1950s was William "Uncle Kit" Carson, who claimed to be the nephew of the legendary Col. Christopher "Kit" Carson. Uncle Kit was later discovered to in fact be a man named Ora A. Woodman, not the nephew of Col. Christopher Kit Carson, as he claimed. (Courtesy HSSNM, #2218.)

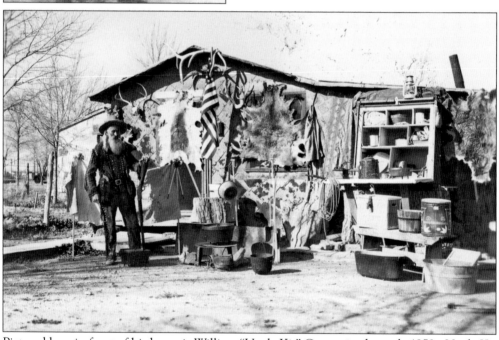

Pictured here in front of his home is William "Uncle Kit" Carson in the early 1950s. Uncle Kit came to Roswell in 1931 and for years could be seen wearing his fringed buckskins, sombrero, and turquoise earrings at various parades and other public events. Uncle Kit passed away on October 23, 1957, in Roswell after just having celebrated his 99th birthday in August. (Courtesy HSSNM, #1214.)

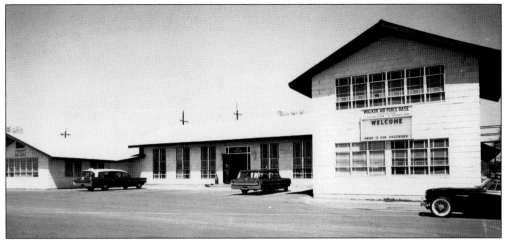

Shown here is the newly renamed Walker Air Force Base's Basic Operations Headquarters. The welcome sign reads, "Pride is our password." The writing underneath the Walker Air Force sign reads, "Field Elev. 3666, 12th Aerospace Division, 6th Aerospace Wing." (Courtesy HSSNM.)

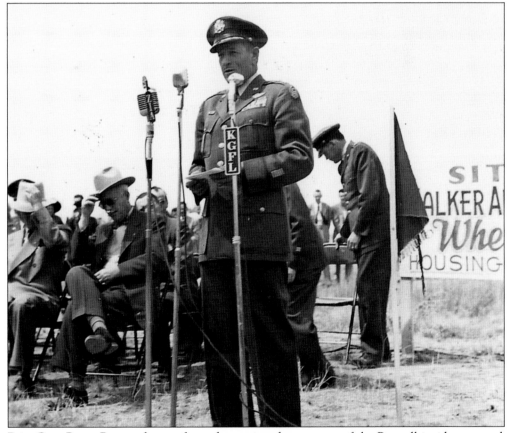

Brig. Gen. Roger Ramey, famous for orchestrating the cover-up of the Roswell incident, stayed involved in the Roswell airbase's well-being. He is seen here making a speech on several radio stations, including KGFL, at the ground-breaking ceremony for the Wherry Housing Project, which would build 800 homes at Walker Air Force Base in the early 1950s. (Courtesy HSSNM, #1883G.)

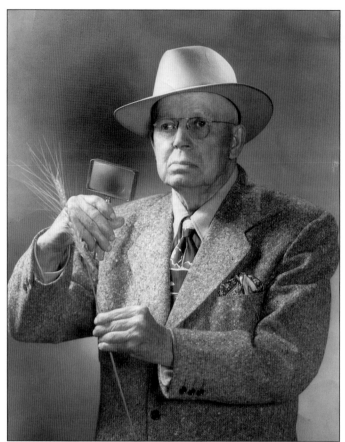

Roswell optometrist and horticulturist Dr. Louis B. Boellner inspects his "super wheat" in this vintage photograph. Boellner served as an optometrist in Roswell from 1904 to 1951. Boellner achieved national recognition for his horticulture and plant breeding, particularly for his Kwik-Krop black walnut and his scented dahlia. (Courtesy HSSNM, #2353.)

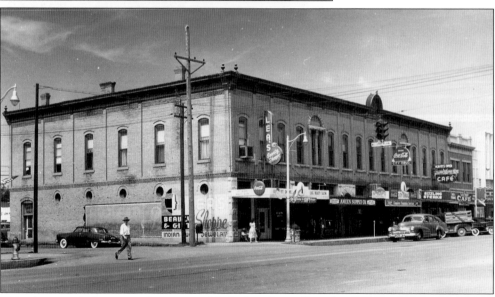

This photograph shows another memorable look at Roswell in the 1950s at the corner of Main and First Street. Among the businesses shown are Lea's Beauty Salon, City Drug, Ameen Supply Company, and Victory Café. (Courtesy HSSNM, #5690.)

Before Barry Bonds broke the Major League record for home runs in a single season in 2001, Joe Bauman of the Roswell Rockets hit 72 home runs in 138 games in 1954. Bauman and the Roswell Rockets belonged to the old Class C Longhorn League, which was part of the minor leagues. (Courtesy HSSNM, #2352.)

In 1956, the town of Roswell won another baseball claim to fame when the Roswell All Stars went to the Little League World Series. The Roswell All Stars traveled to Williamsport, Pennsylvania, the "birthplace of Little League Baseball," where they played against a team from Delaware Township, New Jersey. The Roswell All Stars won three to one. The photograph above was taken in Williamsport. (Courtesy HSSNM, #2139A.)

Roswell mayor Lake J. Frazier (right) and Colonel Hillman (left) purchase the first tickets to the Walker Summer Festival, held from June 30 to July 2, 1962. Little do these men know that, 30-some years later, Roswell will be celebrating a different kind of festival around the same time, the Roswell UFO Festival, celebrated every July since the mid-1990s. (Courtesy HSSNM, #1877.)

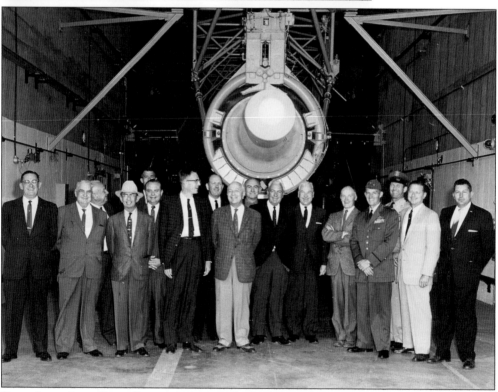

Several prominent Roswell citizens pose inside this WAFB hangar, among them Mayor Lake J. Frazier (ninth from right), Roswell *Daily Record* writer Al Stubbs (11th from right), Robert O. Anderson (fifth from right), J. P. White Jr. (fourth from left), and Hiram M. Dow (second from left). (Courtesy HSSNM, #1877D.)

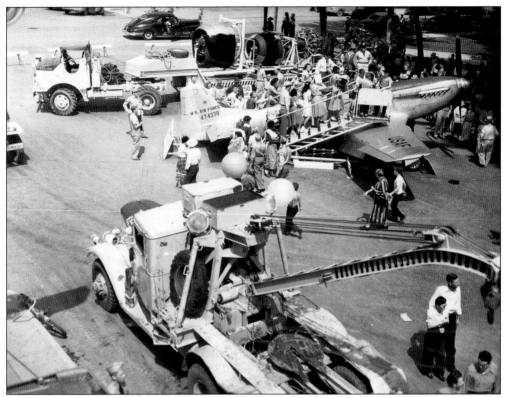

This photograph displays some of the activity at the Walker Summer Festival. The airplane the public is looking at is a P-51 Mustang, one of the most revered fighter jets in U.S. Air Force history. (Courtesy HSSNM, #2052B.)

In 1962, the year before the 579th Strategic Missile Squadron came to Walker Air Force Base, Roswell received its first Atlas missile. WAFB had been chosen as a support base for the Atlas missile silos in 1960. This photograph shows one of the Atlas missiles being towed to one of the surrounding silos. (Courtesy HSSNM.)

All in all there were 12 missile silos constructed within a 25-mile radius of Walker Air Force Base. These photographs show a ceremony celebrating the first missile silo being turned over to the Air Force on October 31, 1961, at Site 10, where visitors were allowed to tour the silo. New Mexico governor Edwin L. Mechem was also there and gave the keynote speech. Accidents suffered at the Walker silos, as well as others across the country, prompted the government to deactivate them. Walker's silos were officially deactivated on March 25, 1965, and the missiles were removed. (Both courtesy HSSNM.)

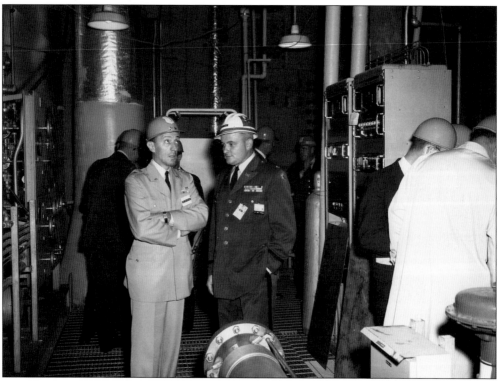

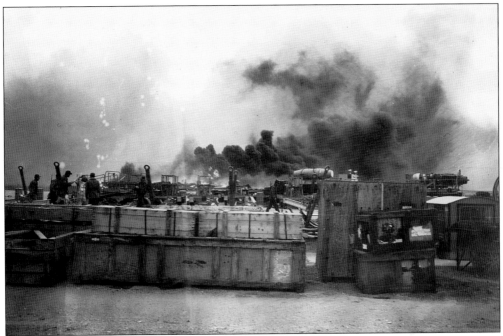

Walker Air Force Base was not without mishaps; in 1959, two men were injured during the testing of a high-altitude balloon. The base also suffered a bad airplane crash in 1956, when a KC-97 Stratotanker crashed, killing 11 Air Force officers. The undated photograph above shows the damaged caused by a B-29 crash at WAFB in a separate incident. (Courtesy HSSNM, #2650A.)

Shortly after the Roswell Army Air Field became Walker Air Force Base, the old base hospital was decommissioned, and the larger structure pictured above was built to replace it. This building still stands today and operates as the New Mexico Rehabilitation Center. Much to the chagrin of ufologists, the old base hospital where the alien bodies from the crash were allegedly taken was torn down. (Courtesy HSSNM.)

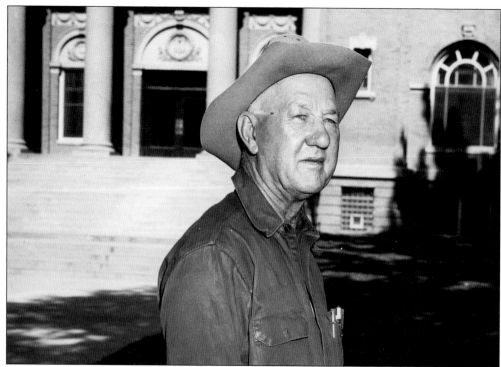

Zeb Chewning was a familiar face in Roswell for nearly all his life. Chewning was the custodian for the Chaves County Courthouse for 40 years. Chewning worked on several ranches in his youth and also as the county maintainer for many years, keeping the roads fit for travel. Chewning lived to see his 100th birthday, which was celebrated in Roswell on March 1, 1984. (Courtesy HSSNM, #2361.)

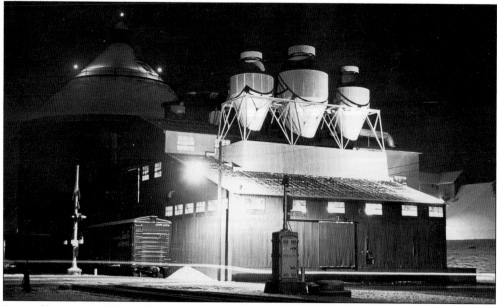

Pictured here is one of Roswell's most familiar landmarks, the Silver Dome over on East Second Street. It was used for a time as a cotton gin by J. P. White Industries. (Courtesy HSSNM, #5700.)

Roswellians were shocked in 1965 when the U.S. Air Force announced that WAFB would soon be decommissioned. Many bases were closing around the United States during the time period because the Defense Department was struggling to pay the expenses of the Vietnam War due to the budgetary limits set by Congress. Rumors abounded, though, that the Roswell base was closed because Roswell did not vote for Lyndon B. Johnson in the previous presidential election. The base officially closed on June 30, 1967. As many of the base residents moved elsewhere, Roswell's economy and population decreased rapidly. With the boarded-up windows of vacant homes and businesses a common sight in the city, some feared Roswell would become a ghost town. (Courtesy HSSNM, #3007B, #4801.)

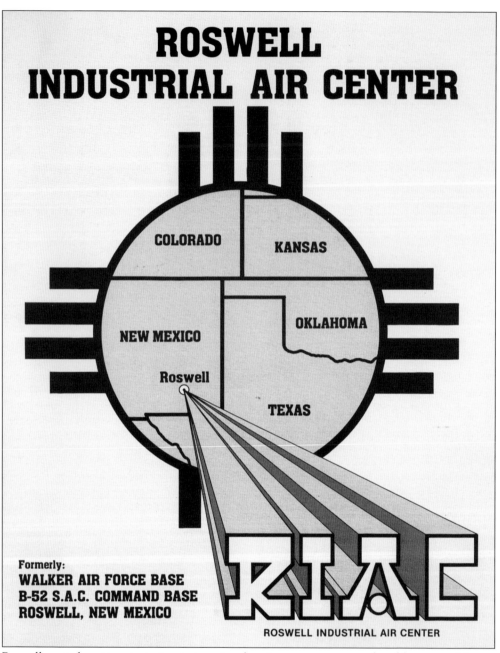

ROSWELL
INDUSTRIAL AIR CENTER

COLORADO

KANSAS

OKLAHOMA

NEW MEXICO

Roswell

TEXAS

Formerly:
WALKER AIR FORCE BASE
B-52 S.A.C. COMMAND BASE
ROSWELL, NEW MEXICO

RIAC

ROSWELL INDUSTRIAL AIR CENTER

Roswell wasted no time in trying to turn its plunging economy around and began working to convert the vacant airbase property into something useful. The first order of business was to form the Roswell Industrial Development Corporation, which converted the old base into the Roswell Industrial Air Center (RIAC). Naturally the city airport moved onto the base, but so did many other businesses, and by the latter half of the 1970s, Roswell was beginning to grow again. Among the many businesses to move to the RIAC over the years were a bus manufacturer, Nova Bus; a Christmas ornament company, Christmas by Krebs; a fireworks company, Longhorn Manufacturing Company; Levi Jeans; and even a lollipop factory, among other things. (Courtesy HSSNM.)

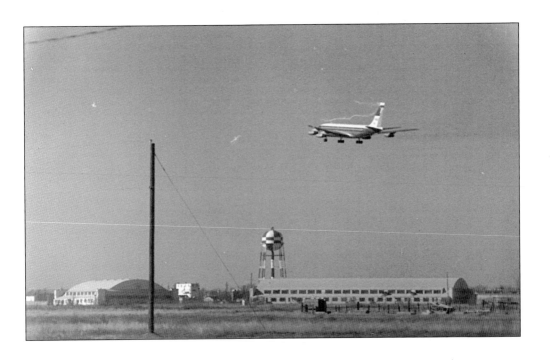

After Walker Air Force Base became the Roswell Industrial Air Center, many aircraft manufacturers and airlines were attracted to the former military base's long runways, among the longest in the world, to use for experimental aircraft testing. Several commercial aircraft businesses moved onto the base, such as Air Lane Aviation, shown in the postcard below. The owner, Art LeMay, and his son, Rodney, were the first civilians to land on the base runway once it was decommissioned, although MPs still showed up to greet and question them. (Courtesy HSSNM, #768A, #2645.)

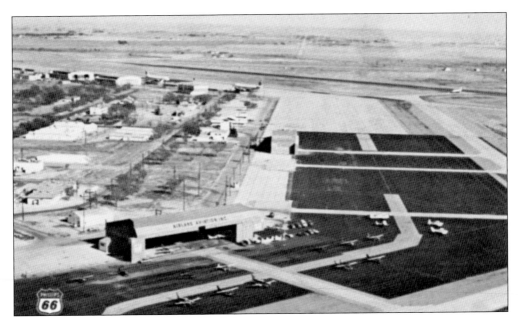

The Roswell Community College moved onto the Roswell Industrial Air Center, using many of the buildings previously occupied by Walker Air Force Base and changing its name to Eastern New Mexico University–Roswell. In the 1980s, it built a new campus and continues to expand. This photograph was taken sometime in the early 1970s. (Courtesy HSSNM, #4659F.)

In 1975, the J. P. White home was donated by White's heirs to the Historical Center for Southeast New Mexico, then called the Chaves County Historical Society, to serve as a museum as well as a memorial to the Whites. To coincide with the bicentennial events of the summer of 1976, the museum was dedicated on July 3 of that year. This photograph shows the opening ceremonies. (Courtesy HSSNM, #676-10.)

Eight

ROSWELL TODAY

By the late 1970s, Roswell had come out of its economic stupor and began to grow again. More businesses arrived in Roswell in the 1980s, and Chaves County was often the leading agricultural county among New Mexico's 33 counties. The dairy industry continued to boom in Chaves County, with some 86,000 cows producing 1.7 billion pounds of milk annually.

In the mid-1990s, Roswell became a tourist town due to the explosion of interest in the Roswell incident. Things hit a peak during the 50th anniversary of the Roswell incident, when thousands upon thousands of tourists and media people flocked to Roswell in July 1997. After this, Roswell's Main Street would forever be changed by a plethora of UFO-related businesses, including the International UFO Museum and Research Center, alien-themed gift shops, and even a restaurant called the Cover-Up Café.

In 2002, Roswell was named an All-America City for turning its 1947 UFO crash into a major part of the town's economy, as well as the Chaves County Youth Dental Initiative, providing dental care to poor children, and for the Dress for Success program, providing schoolchildren with uniforms they were previously unable to buy. Roswell has even finally broken the 50,000 mark in population.

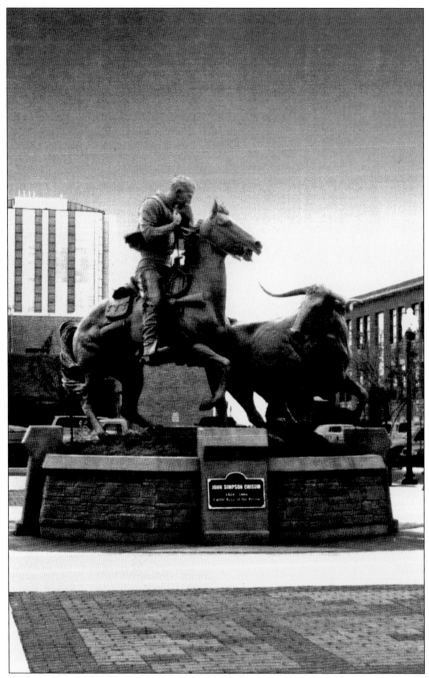

This bronze statue of John Chisum was dedicated March 24, 2001, in Pioneer Plaza adjacent to the Chaves County Courthouse in Roswell with great fanfare. Historian Elvis E. Fleming even portrayed Chisum, complete with a handlebar mustache. The statue was created by talented artist Robert Temple Summers, who has also done statues of John Wayne, Sallie Chisum, and a U.S. Navy memorial in Washington, D.C., just to name a few. The statue was made possible through a campaign led by Stu Pritchard, and statues of Sheriff Pat Garrett and Capt. Joseph C. Lea will hopefully follow. (Jack Rodden photograph, courtesy HSSNM.)

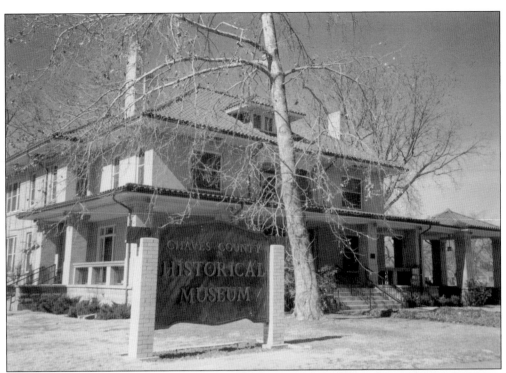

The Historical Center for Southeast New Mexico's museum stands at 200 N. Lea Street in Roswell and is open from 1:00 p.m. to 4:00 p.m. daily. The admission to the museum is free, and inside on the first floor is an array of incredible artifacts and antiques in period rooms from 1912 to 1920. Upstairs are several historical exhibits on World War I and II, schools, baseball, fashion, and more. Next door to the museum is the new archives building, containing over 11,000 photographs, as well as old books, magazines, newspapers, maps, and much more. (Both courtesy HSSNM.)

The Roswell Museum and Art Center and the Robert H. Goddard Planetarium are located on 100 West 11th Street in Roswell. The museum is free to the public, open every day of the week, and features many wonderful art exhibits and historical displays, including a re-creation of Dr. Robert H. Goddard's workshop, shown below. (Both courtesy RMAC.)

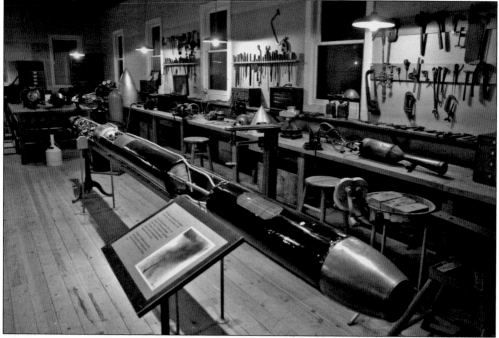

Every July, Roswell celebrates the anniversary of the Roswell incident with two separate UFO festivals held by both the city and the International UFO Museum and Research Center (IUFOMRC). The photograph at right shows the opening ceremonies of the 61st anniversary of the crash at the IUFOMRC. (Photograph by Eva Alexander, courtesy IUFOMRC.)

With its many unique museums and attractions, plus its close proximity to other famous spots in Southeastern New Mexico such as Carlsbad Caverns National Park, White Sands National Monument, and the historic mountain towns of Lincoln County, Roswell is a perfect place to stop and stay for any tourist. Come and visit it soon. (Courtesy HSSNM.)

BIBLIOGRAPHY

Berlitz, Charles and William L. Moore. *The Roswell Incident*. New York: Grosset and Dunlap, 1980.

Bonney, Cecil. *Looking Over My Shoulder: Seventy-Five Years in the Pecos Valley*. Roswell, NM: self-published, 1971.

Carey, Thomas J. and Donald R. Schmitt. *Witness to Roswell: Unmasking the 60-Year Cover-Up*. Franklin Lakes, NJ: New Page Books, 2007.

Clary, David A. *Rocket Man: Robery H. Goddard and the Birth of the Space Age*. New York, NY: Hyperion, 2003.

Fleming, Elvis E. *Captain Joseph C. Lea: From Confederate Guerilla to New Mexico Patriarch*. Las Cruces, NM: Yucca Tree Press, 2002.

———. *Treasures of History IV: Historical Events of Chaves County New Mexico*. Lincoln, NE: iUniverse, Inc., 2003.

Fleming, Elvis E, ed. *Roundup on the Pecos II*. Lincoln, NE: iUniverse, Inc., 2005.

Fleming, Elvis E. and Ernestine Chesser Williams. *Treasures of History II: Chaves County Vignettes*. Roswell, NM: Historical Society for Southeast New Mexico, 1991.

———. *Treasures of History III: Southeast New Mexico People, Places, and Events*. Roswell, NM: Historical Society for Southeast New Mexico, 1995.

Klasner, Lily. *My Girlhood among Outlaws*. Tucson: The University of Tucson Press, 1972.

Metz, Leon G. *Pat Garrett: The Story of a Western Lawman*. Norman, OK: University of Oklahoma Press, 1974.

Shinkle, James D. *Fifty Years of Roswell History: 1867–1917*. Roswell, NM: self-published, 1964.

Smith, Toby. *Little Gray Men: Roswell and the Rise of a Popular Culture*. Albuquerque, NM: University of New Mexico Press, 2000.

Thole, Lou. *Forgotten Fields of America: Volume IV*. Missoula, MT: Pictorial Histories Publishing Company, Inc., 2007.

Tilley, John and Larry Tilley. *Expose: Roswell UFO Incident (Corona Crash)*. Roswell, NM: Lulu, Inc., 2007.

INDEX

www.arcadiapublishing.com

Discover books about the town where you grew up, the cities where your friends and families live, the town where your parents met, or even that retirement spot you've been dreaming about. Our Web site provides history lovers with exclusive deals, advanced notification about new titles, e-mail alerts of author events, and much more.

MADE IN THE USA

Arcadia Publishing, the leading local history publisher in the United States, is committed to making history accessible and meaningful through publishing books that celebrate and preserve the heritage of America's people and places. Consistent with our mission to preserve history on a local level, this book was printed in South Carolina on American-made paper and manufactured entirely in the United States.

This book carries the accredited Forest Stewardship Council (FSC) label and is printed on 100 percent FSC-certified paper. Products carrying the FSC label are independently certified to assure consumers that they come from forests that are managed to meet the social, economic, and ecological needs of present and future generations.

FSC
Mixed Sources
Product group from well-managed
forests and other controlled sources

Cert no. SW-COC-001530
www.fsc.org
© 1996 Forest Stewardship Council

Find Your Place in History.